PORTRAIT
Drawing

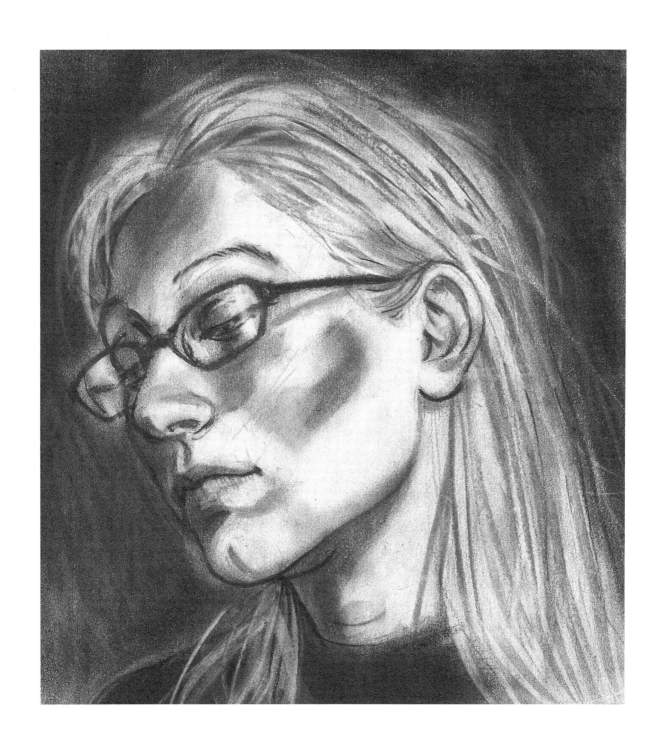

PORTRAIT
Drawing

JOHN T FREEMAN

THE CROWOOD PRESS

First published in 2006 by
The Crowood Press Ltd
Ramsbury, Marlborough
Wiltshire SN8 2HR

www.crowood.com

British Library Cataloguing-in-Publication Data
A catalogue record for this book is available from the British Library.

ISBN 1 86126 854 8
EAN 978 1 86126 854 9

Dedication
To my son William, who thinks the book is extremely boring as he's
heard it all before, again and again and again. I would, of course, like
to thank all those who have lent their faces to, hopefully, a good cause.

Typeset by Jean Cussons Typesetting, Diss, Norfolk

Printed and bound in Great Britain by The Cromwell Press, Trowbridge

CONTENTS

PREFACE

The art of seeing nature is a thing almost as much to be acquired as the art of reading the Egyptian hieroglyphics.

Constable

Frequently in life classes and, surprisingly, amongst committed art students, I am dismayed to see countless drawings of the human form where the face and hands are absent. I am usually offered elaborate, tired excuses about the concern for achieving a likeness or fiddling around with fingers as an obstruction to the more serious pursuit of a big idea such as form, space, or whatever concept is currently to the fore. This is, of course, more often than not simply a case of evading the issue of a basic lack of personal ability; yet it is now justified as a valid way of drawing – one that is liberated from the stranglehold of a reactionary, skills-based elite.

But, ultimately, to deprive a person of their face or hands in a life drawing is to deprive them of their humanity: art, I believe, should always endeavour to celebrate this humanity, not to denigrate it. More importantly, it is an attitude that reveals a lack of empathy towards the subject and an absence of awareness of the fact that it is the artist's own face and hand, their own humanity, that leads them to draw in the first place.

In portrait and life drawing the model should never be regarded merely as a vehicle to be used for pursuing personal conceits and indulgences, or seen as an object for measurement. I therefore hope that this book will encourage students at all levels of ability to engage with the drawing of the human face not as a reluctant necessity but as an inspired, continuous challenge exploring a profound source of elusive wonder. Failing in this, the book can always be used to stop the model's chair from wobbling.

I have deliberately chosen to keep the drawings 'rough' in appearance and construction, in order to maintain an informality and accessibility for the complete beginner. I have also chosen to dwell more on the female face because I believe that it encompasses all of the finer aspects and subtle difficulties encountered within portrait drawing – an opinion that in practice, I hope, you will agree with.

The world has no centre but its fabric and elusive meaning converge and articulate within the Human Face.

INTRODUCTION

To find the mind's construction in the face.

Shakespeare (*Macbeth* act 1, sc. 4)

Understanding the theory and practice behind the visual arts is not dissimilar to that of the art of cookery. There are fundamental rules and processes that have emerged from ancient practice and experience. These basic and essential truths are shared and understood by all cooks, regardless of the diversity of their backgrounds and influences. Ultimately, the essential questions behind all culinary endeavour will be why is it done like that? And how?

In the late 19th century, hundreds of beautiful, enigmatic portraits created two thousand years ago were discovered in Egypt. They are now known as the Fayum Portraits. They were painted using hot encaustic wax which, taking into account its unique properties, influenced the methods of depicting a face. This resulted in the development of a means of breaking down the structure of the human portrait into its essential elements and essence, whilst at the same time maintaining the potential for the individual expression and insights of the artist.

These formulae, the basic grammar behind the language of the face, have remained unchanged regardless of historical developments within figurative art, and are found in artists as diverse as Velazquez and Francis Bacon, and will inevitably continue to be so.

The Fayum Portraits themselves were funerary portraits painted specifically to record a likeness of one now dead. They encapsulate all that is meaningful in a portrait: they depict individuals nameless and forgotten, but for these surviving likenesses. Each portrait stares out at the living, providing evidence of the sitter and also the artist having lived, the sitter's beauty, hopes and aspirations being immortalized by the skill of a stranger's hand and by the knowledge of an understanding eye.

Whether these portraits were commissioned before or after the sitter's demise will, probably, never be known. All that we can assume is that the choices that the artist made in the depiction of the sitter were no doubt to the satisfaction of the artist and the client, and that these choices were not random or fortunate but were informed by discipline and experience.

These choices, as we shall later see, provide the basis for the beginning of a portrait drawing. When you pick up an implement to draw (the Fayum artists used wooden spatulas) you are at once, inextricably, part of a living tradition concerned with the fundamental human desire to make visual sense of the world around and the world within.

The more that you become aware of this tradition and your place within it, the more accomplished and informed your work will become; more importantly, it will enrich your identity as an artist. No-one can work in isolation, as John Constable said:

> Any artist who claims to be self-taught was taught by a very ignorant person.... There has never been a boy painter, nor can there be. The art requires a long apprenticeship, being mechanical as well as intellectual.

Drawing should not be regarded as an indulgent activity, a liberty to express the meanderings of an unfocused mind; although the pleasure derived from realizing your aims within the drawn line is, really no different from that of a child. It will enable you to develop an awareness of the strangeness of the self and that of others. Drawing fixes and makes sense of a shared moment in the continuous flux of existence.

I will, again, emphasize that a drawing is, regardless of subject matter, evidence of your identity, your presence of being there and then, here and now. It is also a mirror to the integrity of your aims. A portrait drawing is an opportunity to clarify and re-examine in the human face those qualities that are easily ignored or taken for granted.

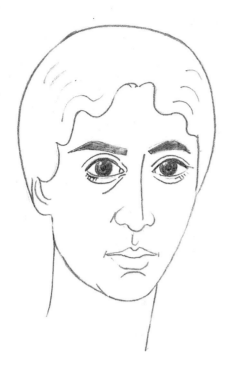

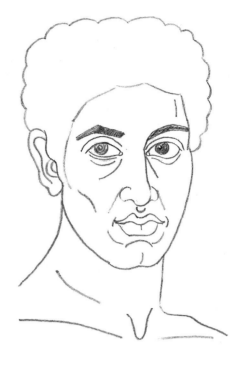

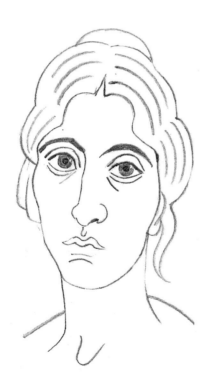

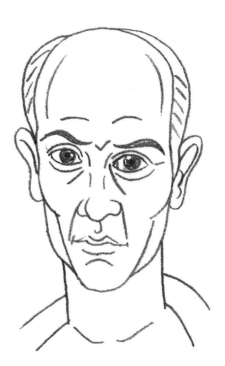

In these linear copies from actual Fayum portraits, notice how the faces have been reduced to the most fundamental and essential lines. These are exactly the same forms that will be used to structure the face. The faces have been stylized to accentuate age and gender.

Making Marks

Drawing is like writing, and just as a style of writing can be examined and analysed by graphology, so can the nature of the drawn line. Most beginners start with a tentative and unattractive quality to their efforts: this is usually due not only to lack of experience but also to an inability to efficiently co-ordinate and transmit information from eye to hand. What is thought to be seen and what is actually seen become confused due to a lack of awareness of the difference between the two and of the discipline to identify them. In writing, the forms of words are dictated by abstract symbols to express abstract thoughts. These can be adapted and manipulated within an accepted format to either state or suggest particular or multiple concepts, but ultimately the act of writing co-exists with the world of ideas.

Unlike drawn lines, words are understood and arranged in a linear manner: letter follows letter, word follows word, and page follows page. Drawn lines are understood and interpreted in a more random and liberal way, their meaning dependant not only on their juxtaposition and realization of the subject matter, but also on the quality and method of their execution.

A drawing is essentially an accumulation of marks informed by the reaction to or the contemplation of visual stimuli, whether they be objective or subjective. The sheet of paper is a flexible and liberating space awaiting your attention. The marks that you make are evidence of not only your knowledge but also of your personality.

Psychological attitudes and reactions to interpreting and solving problems will influence your drawings and their development. Obviously, as your experience and confidence increases so will your abilities, but there is a danger in drawing where style can quickly supersede content. Therefore it is important to realize that the act of drawing should always be seen as an act of learning.

As in calligraphy the appreciation of the physical, tactile, quality of the written line is no different to that of a drawn one, for example, as judged in the qualities of pressure, rhythm, texture and sympathy for the subject. Therefore the methods used in this book are designed to gradually ease the beginner into an informal although structured system of drawing that is not only versatile but will respond to the subjective and objective aspirations of the complete beginner.

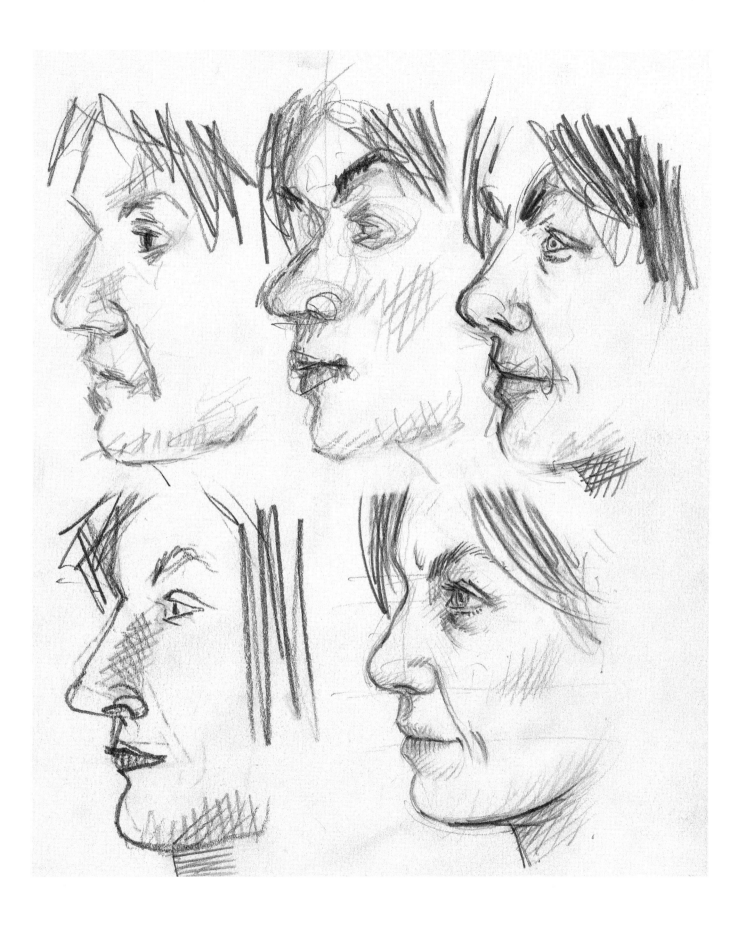

DRAWING WITH THE RIGHT ATTITUDE

Drawing is not the form, it is about seeing the form.

Edgar Degas

Art is a visual language. The image is often seen as a poor cousin of the word, and although its grammar is as diverse and complex as anything in speech and literature it is, unlike them, essentially universally understood. For example, a badly drawn face is a badly drawn face, wherever it is seen.

Drawing is, by its very nature, akin to writing; and as with writing, learning the 'alphabet' is an achievement in itself, let alone using it to make some basic sense. Literacy, like drawing, is a skill slowly and patiently acquired.

When writing a letter it is helpful to be able at the outset to identify and define the reasons for wanting to communicate, which will remain constant regardless of elaboration or digression. In portrait drawing, understanding the means is probably more important than knowing the end. Being forever open to influences within the tradition, which entails assiduously studying images within and outside their historical context, should not be regarded (as is frequently found with beginners) as an optional chore but as a driven necessity.

The essence of art is wonder, an unquenchable desire to learn and comprehend. It is not about acquiring sufficient ability to produce an object for admiration – a drawing is not necessarily about making a picture (there is in fact, as we shall see, a distinction behind the two). Degas once said, when asked why he chose to remain a bachelor:

> I couldn't bear having finished a painting having a wife
> pass by saying, 'Oh, it's really pretty what you've done
> this time.'

Drawing should be seen as a process of problem-solving, utilizing particular areas of the mind that visually comprehend the world.

Avoid short-term aims and solutions and concentrate instead on long-term development. Drawing is, above all, a practical activity. All attempts however ambitious and well intended, begin and end at the end of the pencil and their merit judged against the evidence of the line.

A drawing is and always remains a drawing. It will never be a substitute for, or become one with, the subject; therefore intensity of emotion, howls of 'Art is life, life is art' and 'I capture the soul!' are alas wishful thinking. Art's mystery and revelations are, prosaically, found within its artifice. To paraphrase Robert Motherwell, 'An artist is someone who has an extraordinary way with materials' and Degas, 'In painting you must give the idea of the true by means of the false.'

Finally, there is no greater place to begin your journey into the realms of art than with the human face. It will always be familiar and of interest as you possess one of your own, and residing within the face is the answer to all its questions.

Anyone can acquire practical drawing ability and skills. When I hear anyone say 'I can't draw' it usually means 'I won't draw' due to the fact that the result that they would like to achieve is, seemingly, an impossible task and therefore not even worth thinking about. If, by any means, they are persuaded to give it a go it then becomes a task that seems to preclude any period of trial and error that would normally be expected when acquiring a new skill and instead becomes a very fraught struggle where failure even at the first attempt is seen as a personal affront. This is usually because art is synonymous with creativity and creativity is associated with celebrating the uniqueness of the personality as well as being seen as a romantic, impassioned expression of identity. Surprisingly, even amongst successful artists there is a difficulty in distinguishing the differences between lifestyle and ability. There are essentially two sorts of artists: those who have made a choice to do it and those who have a need to.

One of the fallacies that confuses beginners and amateurs is the idea that the more you do the better you will get. Constant practice without a constructive reason for doing so will eventually lead to a narrow range of subject matter dictated by ulterior motives other than the pursuit of knowledge. It is not *what* you do but *why*. Do not draw to illustrate your feelings, but understand that it is your actual feelings that feed not only your desire to visualize but, more importantly, inform what you choose to depict. A fixation with and a repetitive desire to make sense of a particular eye and not others can be a manifestation, a realization, of subconscious concerns related to the most obscure sources. It is within these idiosyncratic choices and the manner in which they influence their actual depiction that is ultimately the source of that elusive style.

One of the best methods not only to prove to the reluctant that drawing is within their grasp but also to reinvigorate your own abilities is to use exercises which have now become party tricks such as cutting portrait silhouettes and 'seeing with your fingers' (*see* below). Sometimes, especially in Italy, you will see pavement artists cutting with impressive speed and dexterity on-the-spot portrait silhouettes. The secret rests mainly in starting the portrait from the base of the neck and working upwards, constantly angling the paper and not the scissors.

'Seeing with your fingers' is staring at the subject and drawing without lifting your hand from the paper, *not* looking at the drawing at any point. The results will be surprising; they not only convince people that they can draw without looking, but can also help beginners to loosen up and suggest elements that could influence the development of drawing attitudes that could be incorporated within the classical method. It is also an ideal way of establishing the basic angles and structures when tackling perspective.

Preparing Yourself

When beginning a portrait drawing, anxiety can be an overwhelming and crippling problem. Drawing a face is like learning to ride a bike, although less painful – unless an offended model pokes you in the eye! Anxieties about achieving the desired results sooner rather than later can stifle development and lead to a crisis of confidence and, at worst, defeatism.

Try not to let the subject matter intimidate you or dominate the proceedings. Try to remain pragmatic, concentrate on the physical activities of drawing and come to realize that a successful drawing is an accumulation of fewer mistakes than the previous one.

Try to see the activity as a dialogue between yourself and the drawing. As you would hope from a productive conversation, there should be mutual compromise, diversity and potential for development. As Oscar Wilde said, 'When two people keep agreeing one of them isn't thinking.' If either party dominates, it will lead to inertia and the inevitable boredom.

An authentic, humanist work of art should never lack genuine interest. Any superficial attempt to disguise a lack of integrity such as resorting to glibness, tricks and clichés is only self-deluding and self-defeating. And whatever bouncy, brightly coloured, 'artistic types' tell you, art is not fun either. The fun is found in spending the money from your first commission. Therefore, to reduce anxiety the beginner must try to do the following:

1. Take on one thing at a time.
2. Decide what that particular drawing is concerned with: how the hair falls, the shape and size of the ears, how the neck connects to the jaw, and so on.
3. Do not focus all your concerns onto one drawing. Spread them across as many sheets of paper as necessary until you feel confident enough to proceed further.
4. Obviously, achieving a likeness is paramount, but try to reassure yourself that to arrive at a likeness is a laborious process.
5. Don't be deceived by the facility of others. Many artists in the past have, for many reasons, been at pains to create the illusion of spontaneous virtuosity in their work.
6. In each drawing, decide to pursue a different line of enquiry. The memory of each technical discovery, if systematically arrived at, will not be forgotten because the method resides in the eye and hand, not in the mind. Do you write or make a sketch of your name? Whatever you learn in practice, you will never forget.
7. Be prepared for grubby mistakes, imperfection in everything and restraint in everything, even in excess.

A standard portrait study.

The same pose drawn by 'seeing with your fingers'.

THE PROBLEM OF STYLE

Style is your signature. Something, like yourself, that is personal and unique. Or is it? For all its overtones of subversive skill and deception, forging a signature is a rather prosaic technique and is a variation of a method frequently used by portraitists to help them acquire a part of someone's identity. This entails divorcing what is seen from what is known, and reversing the normal procedure of visually understanding things in order to perceive them more objectively. The key thing is to switch off and maintain the flow.

Turn the signature upside down. Starting on the left, objectively copy the shapes of the letters. Do not lift your little finger from the paper: keep in contact, allowing your eye to transmit information as it is received. Allow your hand to slide freely across the surface and continue to draw whilst looking at the subject. Do not stop to think about what you are doing.

Style consists of an accumulation of personal choices. Style is when your methods seem to be the only possible way of doing it, when the character and nature of your work comes close to what you intended. Style can be received good taste or an intuitive combination of disparate elements. Style can also be acquired – especially when beginning – by imitating the work of someone else whose style you admire. This way you endorse your own work, with the benefit of hindsight, with some degree of critical security.

Style can also be derived from simply being inspired by another's work and the pleasure derived from respectful imitation. This usually is the most productive method of, indirectly, developing your own intimate point of view.

John Constable said 'In art there's no such thing as boy genius'.

To conclude the introduction, it may be helpful to keep in mind as we begin to draw a portrait these suggestions:

1. When starting to draw, be conscious of the present moment.
2. Do not drift into the act of drawing with an unfocused mind.
3. Do not assume the role of an artist and then imagine that what you produce is therefore art.
4. To begin with, allow your rationality and common sense to guide you gradually into the open reaches of intuition.
5. Allow your eye and hand to work in unison to overcome the inhibitions of what you think you see.
6. Maintain a spirit of honesty and patience: honesty about your weaknesses and knowing that patience will overcome them. And remember that the Great Masters, however bohemian and touched by genius they may have been, all actually enjoyed watching paint dry.

Preparation

When beginning, do not use any materials that you have inherited; buy your own and begin anew. Do not take your materials for granted. One sort of pencil will not do for another. The pencil and the texture of the paper will respond to and enhance your aims and results.

The Pencil

The most useful general purpose grades are a B used in conjunction with 2H, 2B, 6B. Others should include 3B, HB, 4H, 6H.

Charcoal

Compressed charcoal B, 2B, 4B.
Willow charcoal in assorted widths.

Sharpeners

A standard pencil sharpener.
A sharp craft knife.
A sheet of smooth sandpaper.

Paper

Preferably a smooth off-white (light cream) paper such as 'Arboreta'. Try not to use bright white cartridge paper, because the quality of line becomes limited, weak and severe.

Paper is a surface that receives your attention. Should it be seen as a window for the eye to enter into or a wall for the eye to rest upon? Without being aware of these differences it is very easy for the work to sit uneasily between the two, resulting in an effect as uncomfortable as mixing metaphors. When starting out to draw there is a natural tendency to use the pencil as you would a pen. This greatly limits the range of a drawing's potential.

A *drawing* is, usually, a direct response to external stimulus and works within its own framework of rules almost like a game of chess. A *picture* is when concepts outside of this framework are introduced in order to enhance or exploit the subject. This can result in turning a clear objective statement into a confused and indeterminate one, although sometimes maintaining a tension between the two attitudes can generate a compelling quality within the work which can be easily lost, or quickly become tiresome when it is contrived or is self-consciously seductive. It is possible that a successful work of art is a balancing act between refinement and vulgarity.

Unlike writing, which is essentially confined to established patterns, drawing is simply mark-making: the variety and nature of the marks are to some extent defined by the subject being drawn.

Using the Pencil

Familiarity with the range and possibilities available is of course essential. It is best acquired, naturally, in the process of drawing rather than in the absence of a subject, though an easy and effective way of practising is simply to keep doodling. Become aware of the differences and properties of each grade of lead and (this is particularly important) that a pencil lead has an edge as well as a point. The edge is used for exploration and generalization, the point for definition and delineation.

It is important to gradually get used to using three varying grades of pencil within a drawing just as a carpenter would use chisels, or dentists their drills. They are shown below.

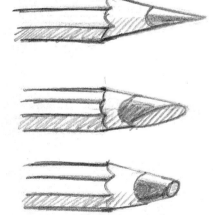

The first pencil must always be kept sharp

The second with an edge rubbed flat (on sandpaper). This is used for modelling with shading.

The third is used for heavy, expressive lines.

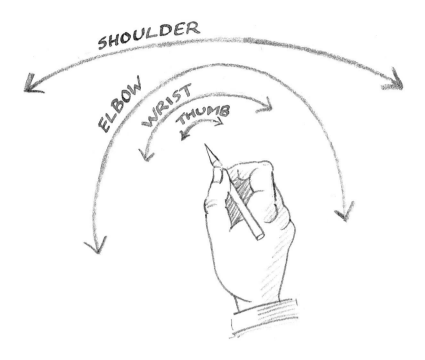

The Basic Holds and Moves

1. The use of only the thumb and forefinger to manipulate the pencil. This limited range of movement is ideal for the specific and detailed delineation of form in specific areas. To use this method alone can result in the drawing and the process of observation becoming fragmented and stilted.
2. The pencil can be held rigid by the thumb and forefinger with the movement controlled from the wrist. This is ideal for shading, blocking in (quick, broad strokes) and establishing general form.
3. The thumb, forefinger and wrist locked rigid, thereby allowing for movement to be carried out from the elbow. This enables a wider defined, encompassing line to be achieved, particularly for circular movements.
4. When starting to draw, all three points of movement can be locked and the shoulder can be used to establish comprehensive, wide, long, continuous bold lines. This movement is ideal for composing complete figure portraits.

It must be understood that a continuous combination of these positions – wherever each is applicable – should be used even within the drawing of a *single* line, whatever its scale.

Above all, remember to keep the pencil sharp at all times. This not only prevents inaccuracy but provides, while you are sharpening, brief natural interludes in the drawing process that allow for subliminal reappraisal of the work's progress and small but essential spurts of renewed vigour and interest in the exercise.

Holding the Pencil

Where you hold the pencil may appear to be a trifling detail, but it is an integral part of producing the right kind of line in sympathy with your feeling towards what is being drawn.

The further down the pencil is held, the more pressure is exerted, resulting in a harder, more emphatic line. Therefore, to

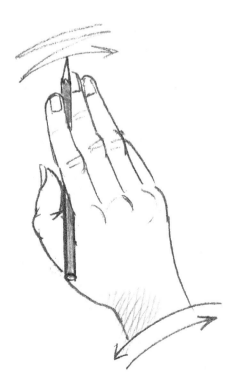

create variations in texture and mood, adjust the position of your grip accordingly: light, feathery strokes would be helped by the pencil being held towards the end.

Rhythmic shading strokes are more effectively produced and controlled by resting the pencil between the index and second finger, and drawing from the heel of the palm.

It must be emphasized that the degree of pressure applied to the line is a critical aspect in the development of expression within the image, such as when emphasizing contours and the dynamics of hair. When drawing, try to keep a light touch and be sparing with definition: heavier, sharper, lines can be super-imposed for emphasis, but refrain from using continuous emphatic lines as the drawing can become stifled and precious, and can veer towards resembling a diagram. Break a continu-ous line by varying the pressure of the pencil, for example applying it lightly where light touches a surface and heavier when in shadow or describing tension or support.

Do not feel the need to make a 'tidy' drawing. Allow the qual-ity of the line and the grubbiness acquired in its execution to reflect the imperfections of even the most perfect visage. Do not idealize. The grubby marks can always be erased at the end, but then again do not overdo it – just remember that it is a drawing, not a piece of furniture.

Finally, as a rule, do not use pencils that have been reduced to half their length. Do not hoard them either: dispose of them or use them to make little Swiss chalets that can be an ideal thank you gift for the model.

sharp at all times, using the stump of the other end for general rubbing out.

Posture

Choosing to stand or sit to draw can affect the attitude and progress of the drawing. If you are using an easel it must be positioned at a right angle to the subject, not directly facing it. This ensures an unobstructed line of vision; otherwise, your head will in effect be playing peek-a-boo with the sitter.

If you are sitting, the drawing board must be positioned at a raised angle. It must never lie flat because this will distort the drawing.

If you feel uncomfortable in any position, just think that it didn't seem to bother Michelangelo.

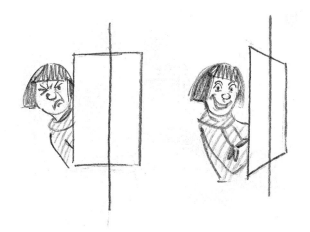

The Eraser

The eraser, as you will see further on, is as important as the pen-cil in drawing. Do not regard it simply as a means of correction, but as a means of introducing another method of drawing; the subtraction/reduction of lines, as well as the addition of them, is essential in an accomplished drawing. The line does not have to be dark to be a line. Keep one end of your plastic eraser sliced

The Model

Before we begin, let us not forget the model – a thing easily done in the self-absorbed world of art.

The model should be the only person who is posing. Artistic airs, graces and sulky moods from the artist do not exactly impress or inspire confidence. Chesterton said that 'The artistic temperament is a disease that afflicts amateurs.' Behave in front

of the model as you would in front of a lawyer for the prosecution. Remember that you are in an extraordinary situation where a stranger has agreed to remain still and silent, and then to be stared at to a degree that elsewhere could find you before a judge.

The fascination of portraiture is probably in the universal human desire to be of interest to others and the corresponding fear of being ignored, which applies equally to the artist as to the sitter. Therefore courtesy and consideration is due to the model at all times. And if you hear yourself say something like 'I had the drawing just right, but then she moved', try to imagine that Dr Johnson might have said that blaming the model is the last refuge of a scoundrel.

The Pose

When starting out, do not set the pose at an 'interesting' angle. Try to keep it simple, preferably with the head upright and looking straight ahead, and try to develop an attitude that obliges *you* to move to draw from a different angle, rather than the model. This is because there is a tendency for students, once they are set up and comfortable, to seem to feel that the world revolves around them. This inevitably leads to attempts to realign the model to conform to the artist's mistakes, which undermines the whole concept of learning to draw.

It is also quite common for portrait groups to be concerned with how the sitter is dressed in order to make the portrait more of a 'picture' and 'more interesting' to draw and to look at. This attitude obviously also dismisses the actual theory and practice of portrait drawing as irrelevant, as well as reducing the sitter to the status of a manikin.

Preparing Yourself

Before we start, here are some guidelines to help ease you into your first portrait drawing. They are not only to help clarify, once again, the reasons of how? and why? but to ensure that portrait drawing comes to be seen as a specific occasion as much as an activity.

1. Try not to use sketch books, because they have a tendency to encourage bad habits such as preciousness, tidiness and a systematic desire to fill the book as evidence of achievement. Using loose sheets of paper not only prohibits this but encourages a more liberal and informal approach to drawing, and gives the opportunity to use different types of paper.
2. Position yourself at a socially acceptable distance from the model. If you can reach out and touch, then you are probably too near, and if you can't see a pimple you are probably too far.
3. Settle down. Organize your mind and intentions. Consider your materials and how to make constructive use of the time available.
4. Have no expectations. Try to suppress any anxieties about performing well.
5. If you fail at the first attempt you can always destroy it. Remember that you are under no obligation to show your efforts to anyone.

With regards to the model, even if it is a commission you are at the end working solely for your own benefit and education. If this is forgotten, the desire to please can lead to the use of glib tricks and formulae to overcome the fear of appearing inept.

Becoming Familiar with the Form of the Face

Recognizing the differences between the age, gender and race of faces is usually taken by the beginner for granted. But the potential of one to evolve into another contributes to the subliminal fascination and intrigue of a portrait. Although some faces will possess defining characteristics of each category, many will hover on the cusp.

Once you are aware of the subtleties involved, it follows that your drawing ability should be capable of engaging with them. A heavy hand, an ill-conceived line, a misuse of materials will soon become apparent and will be continuous obstacles.

The quality of line should strive to be in sympathy with the feeling that one has when observing, for example, the surface of the skin where it is close to the bone or the hardness of the bridge of the nose in contrast to the softness of the cheek.

Our knowledge and understanding of the face is based on seeing it constantly mobile. Each component – the eye, the mouth, the angle of the nose, the shifting of the hair – are in continuous individual movement, which influences and affects how we react to the face as a composite entity.

Another thing that can be easily overlooked is the artist's own physical presence in the proceedings, and not as some sort of detached observer. The personal level of attention to each aspect of the sitter's face depends uniquely on the artist's preferences. These can be influenced by how the sitter reacts to the situation, whether they are uncomfortable or amiable. Another decisive element of drawing is that it is a specifically impersonal activity, where tactile communication would be like disturbing the surface of the water.

The portrait remains, regardless of the human presence in its creation, a silent, still and distant object.

INTRODUCING THE METHOD

He who does not know the mechanical side of a craft cannot judge it.

Goethe

The method of drawing that is used throughout this book is sometimes referred to as the 'classical method'. It is a method of observation where the edges of the subject, be it a face or a fingertip, are arrived at by moving outwards from a central point of reference. This central point is not a fixed point of departure and can begin at the centre of anything, regardless of scale, that is being drawn.

The other method which is commonly used, especially by the untrained, is known loosely as the 'modernist method'. Here the outline takes precedence, and the method is primarily concerned with style rather than content, as opposed to the classical method. It must be noted, though, that in more advanced drawing techniques both methods are utilized.

> Pictures are not, as some people think, images of something. In other words they do not express an idea; they are an idea.
>
> Eric Hebborn

Before you begin to draw, pause a while. Simply look at the model, look at the blank piece of paper. Try to visualize, to project, the model's face onto the paper.

Now imagine that you have just entered a dark room. At first you are disorientated and unable to see clearly. Gradually, as your eyes adjust you begin to make out basic shapes. Slowly the shapes emerge from out of the darkness and stirrings of recognition begin.

As the light increases you start to notice the relationships between the shapes taking form as their definition slowly emerges – you begin to make comparisons with things that you already know. Soon the increasing levels of light allow you to identify the particular properties of each shape: its position, scale and how it relates to other elements around it. As you remain focused on what is before you, a sense of meaning gradually becomes apparent and familiar. Soon you become at ease with what's before you, and have the confidence to begin to draw.

The Size and Shape of the Head

Our concept of the scale of the head is affected by the fact that it is usually seen at constantly changing distances, and its comparison with the size of the body is hindered by clothing.

A big head is usually due to the size of the forehead, and vice versa. Therefore, to make things easier for beginners the first part of this book will be concerned with the face up to the eyebrow line; the forehead and hair will be examined separately.

A general guide to the scale of the face is to use the outstretched hand. The distance from the heel of the palm to the tip of the middle finger should cover the distance between the chin and to just below the hairline. Anything larger than this can create problems, not only in controlling the dimensions of the face but also by affecting the subjective relationships between the individual features.

The eye prefers to assimilate information from within a compact area. If the eye has to wander and hesitate, natural processes become tiresome. The large spaces that result between

areas of intensive activity are prone to unnecessary attention, for example, superfluous brushstrokes in paintings. Therefore, for the benefit of the coherence of the image it is important to try to maintain tension between all the elements within the drawing. This can be achieved by reducing the connections and the distances between each drawn line by using the natural span of each movement of the hand when drawing.

The range of the fixed wrist moves through approximately four linear leaps. This also applies to the range of the fixed thumb and forefinger. Therefore, try not to stagger or extend the line beyond this optimum range of movement.

A good example of this problem can be found in the area between the nostril and the earlobe. Nothing much goes on in this area except the connecting presence of the cheekbone. If this area is allowed to predominate, the distance between the face and the ear has the same effect as looking on a map where the distance between two countries is divided by a desert.

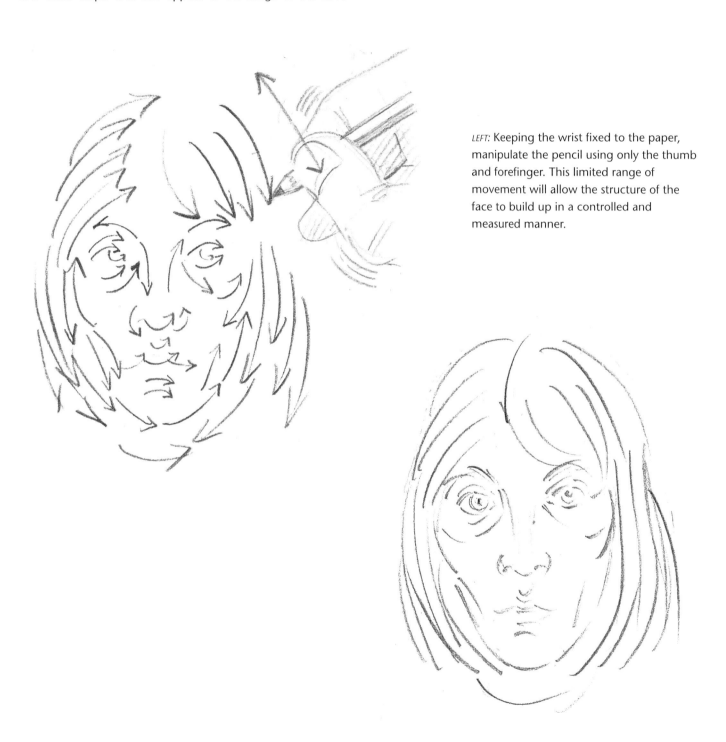

LEFT: Keeping the wrist fixed to the paper, manipulate the pencil using only the thumb and forefinger. This limited range of movement will allow the structure of the face to build up in a controlled and measured manner.

Using the Eraser

One line alone has no meaning, a second one is needed to give it expression.

Delacroix

The continuous erasing throughout the drawing process ensures that you do not become complacent or, indeed, precious with the progress of the drawing. Erasing is a constant reminder that at this stage in your drawing you are in the process of forever arriving.

It is important to understand that the erased lines are not an admission of failure, rather they are an integral part of the actual drawing. They are evidence of activity. In technical terms they are known as 'pentimenti' or, more prosaically, as under-drawing; they contribute to the drawing a personality and a warm, subtle, infrastructure to complement the later bolder and more definitive lines. In fact, when I have been asked by picture dealers for my opinion in identifying suspected forgeries, the first thing that I would look for would be the absence of underdrawing, because a forger works with the benefit of hindsight – unlike the original artist who worked towards an end without any.

Therefore do not regard your eraser as a last resort because, used in tandem with the pencil, it will result in the making of harmonious decisions and subtle compromises.

Of course you must always be prepared for and accept mistakes (portrait classes never seem to figure in corporate management team-building weekends). Welcome and encourage them by taking risks and tackling areas that you might wish to avoid such as nostrils which, like the genitals in a life drawing, tend to be confronted last. Come to realize that making good art is in making the right choices of where to start and where to finish, and what goes on in between.

The Point of Departure

There is no work of art that is without short cuts.

Gide

Before undertaking the daunting prospect of a portrait a basic understanding of anatomy should be necessary. Unfortunately this is often now not regarded as an essential requirement, probably due to it being considered reactionary and culturally incorrect. Therefore we shall start by looking at the structure and form of the skull alongside that of a basic face, not only to give some meaning to the face but also as an ideal introduction to understanding the theory and practice within the drawing of a portrait. This approach will also introduce the different attitudes towards the drawn line that are relevant to each stage

of the drawing as, for example, in the level of attention to accuracy and in the speed of execution.

The most important practical rules that apply to beginning a portrait – and their use must become second nature – are the placing of the four lines of the face. Please note that at this stage in the drawing accuracy is not essential, and can even become a hindrance. The four lines create an approximate infrastructure for the face; they are used to be worked against, rather than followed, when developing the drawing with the introduction of more specific and informed lines.

The very first thing that is established before continuing with anything else is the oval of the head. This shape is an ideal general-purpose shape for the head, regardless of the subject's actual one. At this stage, as will be emphasized again, accuracy is not a priority but establishing the correct scale is very important. For the purposes of drawing all the angles, postures and aspects of the head, try to imagine the oval as an egg with the four lines of the face drawn across and around it. As the egg is tilted the lines will curve upwards or downwards and the spaces between them will alter as the features would do on an actual face.

Remember that the actual proportions of a particular face are not *imposed* but are systematically *arrived at*. I remember my mother drawing faces on eggs to encourage me to eat them and then bash their heads in with a spoon. Stalin boasted that it took many eggs to make an omelette – I sometimes wonder whether his mother did the same! I also believe that many prominent artists today would find the prospect of drawing on an egg either too taxing or would require lengthy consultations with their dealer before trying.

Remember that the positioning of the oval on the paper is just as significant and important a stage, if not the most important stage, as any other in the drawing. For if it 'feels' right, this feeling will be sustained and will continue throughout the portrait.

The four lines are now introduced in the following order, as shown on page 22:

1. the eyebrow;
2. the nose;
3. the bottom of the nose;
4. the centre of the mouth.

The Eyebrow Line

The eyes are the first point of social contact. You are now in a situation where you can stare into someone's eyes with good intentions.

The eyebrow line is an important line of reference when drawing not only a portrait but also the human figure. If the stu-

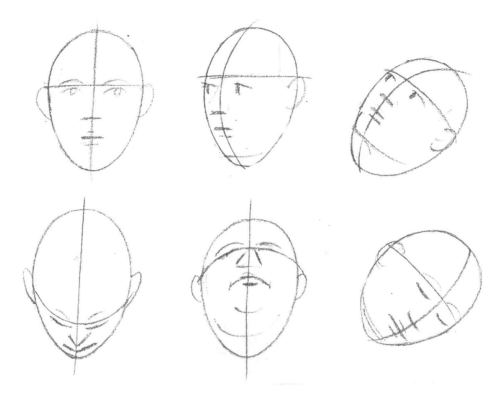

dent, for want of knowing any better, chooses to ignore this then, with regards to this book, they might as well stop here.

The entire body hangs down from this line. It can be used as a constant point of departure, a point you can return to and regain your direction from. The point between the eyebrows, above the bridge of the nose, is like the source of a waterfall, the body first trickling, then flowing and spreading out and down from this point.

Here you begin your journey. Imagine a map. Your line wants to travel from A to B. Seen from above, the route is clear. In reality you will have to negotiate hills and valleys obscuring or enhancing your direction. At any point you can lose your bearings but, knowing where you began and, like Theseus in the Minotaur's maze, that your line will lead you back to the eyebrow line, will alleviate a lot of anxiety that can frustrate your ambitions.

Do not regard your initial scribbles as random and undisciplined. They are honest and informed. Remember that you will be working from the general towards the particular, as if you were adjusting a lens slowly into focus. I realize that making an initial mess is anathema to those with a tidy mind or those who expect instant satisfaction. Therefore, if this is you, try to imagine that the builders have just moved in and you can't go on holiday.

Moving to and fro from the eyebrow line will also gradually, with practice, lend momentum to the drawn line and therefore to the structure of the head. Just as in life you would quickly build up an assessment of a face in a continuous movement of

the eye, shifting from eye to mouth and back again as the subject constantly alters their viewpoint.

This optical rhythm between physically different points of reference creates a fusion of all their qualities that creates a recognizable identity. Therefore, in drawings it has the effect of making a precis of the face, eliminating unnecessary details in order to focus on prominent aspects which, eventually, will take the portrait closer to capturing the elusive 'soul' of the sitter.

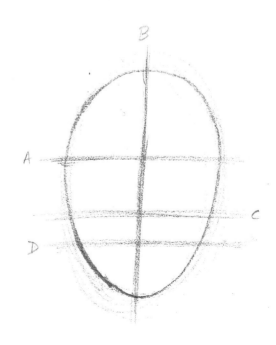

The Nose Line

The next line to be introduced is the nose line. The placing and direction of the facial features can be placed and measured down along this line. By using a combination of both the eye line and nose line you can begin to make basic sense of the face.

Do not confuse the length of the nose line with the actual length of the face. It must be seen and used as a means to enable the features to move up and down the face, as well as providing a central spine to prevent the face veering off in all directions as the drawing progresses.

When observing the subject's face, try to roughly measure the time it takes to move your eye between each feature as you assess the appearance of the face. For example, do you linger for a fraction longer on the space between the eyes, or the size of the lower lip? This will enable you to create and contribute a subliminal momentum to the drawing process, which will add to the overall cohesion of the facial features.

The Bottom of the Nose Line

This line should be regarded as a midway point, where you should rest and reassess what has been achieved above and below it. Do not regard it as the centre of the face, or think that it equally divides the face – theoretically, the eyes are the central focus of the face.

The Centre of the Mouth Line

This line not only enables you to position the centre of the mouth, but can be used as a line of reference to establish the structure of the jaw and chin.

Now having established the fundamental lines of structure and reference the portrait can be developed accordingly.

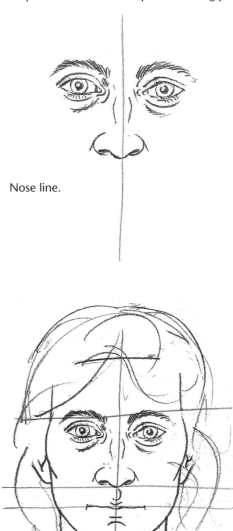

Nose line.

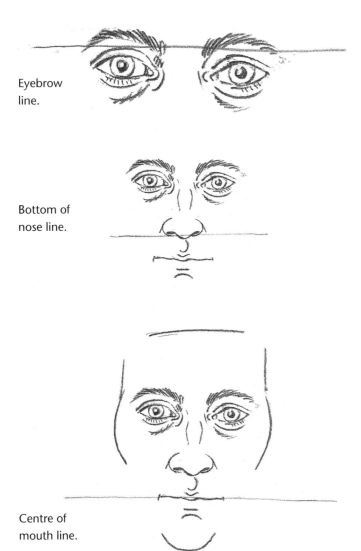

Eyebrow line.

Bottom of nose line.

Centre of mouth line.

Further Preparations

Having first meditated upon the subject, you can now more objectively look at the physical dimensions of the paper and the space available for your hand to move in, and decide where the portrait can be placed to its best advantage. To do this, begin by miming: blocking in an imaginary drawing of the subject before you. Moving your hand over the paper without touching the surface with your pencil. Not only will this exercise ease you into the act of drawing, but it also initiates hand and eye co-ordination. Maintain the attitude towards drawing that it is a continuous process of learning and understanding. Remember that all aspects of beginning a drawing, however seemingly insignificant at first, are essential in helping to establish a responsive frame of mind.

When beginning to draw, gradually acclimatize yourself by making small individual studies of facial components (the more difficult, the better), rather than tackling the subject 'head on'. Making preliminary studies (the term 'sketch', as used nowadays, conjures up for me a compulsive, mindless, jotting) gives the model and the artist the opportunity to engage in conversation, thereby creating a more informal atmosphere.

An important point to understand before you begin to draw is the role and function of measuring. Many people who have had experience of life drawing may have been taught, or may have observed, the use of the pencil or thumb to gauge

proportions and distances. This method is not encouraged or used in this book because, although it may give you an air of seriousness, it actually has several drawbacks:

- The act of drawing is stopped while you squint and wiggle the pencil. Also, the pencil actually becomes a barrier and in effect blocks your view.
- You will tend to *think about* – rather than respond and relate to – the relationships between shapes, in an organic and subjective way. This reduces the subject to a series of basic assessments that run the risk of becoming mechanical generalizations.
- The act of drawing is turned from a process of discovery and understanding into an intellectual, impersonal, exercise.

Therefore the method of measuring used in this book is based on an informal and gradual accumulation of information and understanding.

Theory into Practice

As has already been mentioned, a suitable metaphor for the processes and methods of art is cooking. Therefore, to familiarize the stages of preparing a portrait and to aid the memory, each section is titled accordingly.

First Fry your Onions

When you begin to scribble, try to keep your little finger in contact with the surface of the paper at all times. This will prevent pausing to think, will allow the hand and pencil to move smoothly across the drawing, and will help to maintain a natural scale to what you see and what you draw.

Start to scribble; make a mess. Keep your eyes on the model and use the lines of the face as your guide. Remember that thinking gets in the way. You are, as a French expression says, 'as stupid as a painter'. Allow your hand to move freely across the paper. Do not lift your pencil from the surface. Acclimatize your eye by accumulating lots of lines. As Ingres said to Degas, 'Make lots of lines, lots of lines.' Do not hesitate. Do not interrupt the flow of information. Do not allow what you think you know to tell you what you think you see. Keep your eyes on the model. The longer that you look away from the model to draw you are, in effect, drawing from memory.

Now you have broken through onto the paper and have opened up your eye and unlocked your hand. Building up speed and momentum will eventually, as many experienced

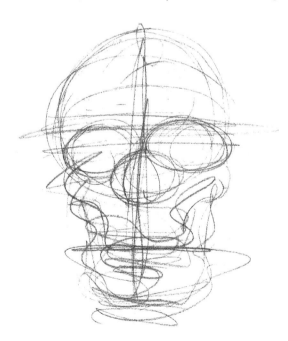

ABOVE: Do not allow your hand to leave the paper. Allow the hand to respond to the eye's instruction without the intervention of thought and its preconceptions. The basic geometry of the face will naturally and gradually make itself apparent.

artists will confirm, bring you to a sudden point where the materials have become apparently strangely receptive and malleable in responding to your wishes.

These are the first responses. You have stirred the surface of the depths with a finger and now it is time to wade in. Having covered the surface of the paper with lines (lots of lines!) and having established the nose and eye lines, you now gently erase all of the lines with the side of the eraser until they are barely visible. These will become the guidelines for the next stage of the drawing. You can now begin to draw again.

It is common amongst those unfamiliar with drawing to naturally draw a line using a tentative, stroking action. Refer to the picture on page 10. Not only does this fudge the decision to make a decisive line but, presenting half a dozen to choose from, it offers the hope that at least one of them is right. This habitual, nervous tremor can result in not only re-enforcing an error but giving the face a hirsute appearance. This is another reason why the use of under-drawing (pentimenti) with the eraser is quite critical as a means of preventing this problem occurring.

Therefore, to emphasize the above, the beginner must maintain a rhythm within the passage from one line to another. Any tension lost between the features can result in diminishing the character and credibility of the portrait. Imagine a line of love poetry recited in a quite measured way suddenly shouted, each word over-emphasized, in an attempt to achieve a clumsy, greater effect.

Add your Ingredients

Begin by re-establishing the eyebrow line and the nose line and, starting at the centre of the eyebrow line, block in the left-hand orb; then repeat with the orb on your right. Next, continue downwards along the nose line, introducing the triangle of the nasal cavity and the oblong of the teeth. Then block in the general shape of the skull's outline.

Using these preliminary structural lines as a guide, proceed to strengthen and alter them into more specific forms, remembering to keep up the momentum.

Give It a Stir

Gently erase the drawing and use the remaining lines as further guides. Unless you are left-handed, always begin with the left-hand orb. This is not only a practical place to start, but is psychologically comfortable for those who read and write in the Western manner and will help you to proceed in developing the image with confidence, discovering more specific shapes and contours. You are now establishing a rhythm and a vitality to your process of drawing. This will also prevent you from becoming too controlling with regards to how you would like the drawing to be: that would seriously undermine any progress that you would hope to achieve, by reducing the very act of drawing to a formula of almost foregone conclusions. Once you feel that you have established the essence of the subject, then it is time to grit your teeth, reach for the eraser and…

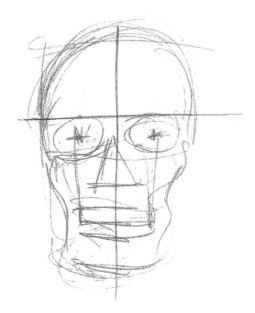

ABOVE: Remember that at any stage in a drawing, even when just observing, apply the method of working from the general towards the particular. Reduce initial responses and non-essential guidelines through gentle erasure. The importance of the eyebrow and nose lines should now be apparent.

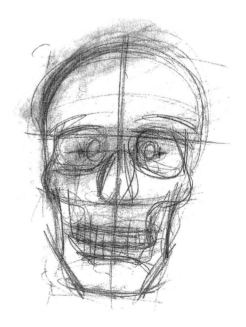

ABOVE: Now, confidence increases, strengthen the lines with a finer hand.

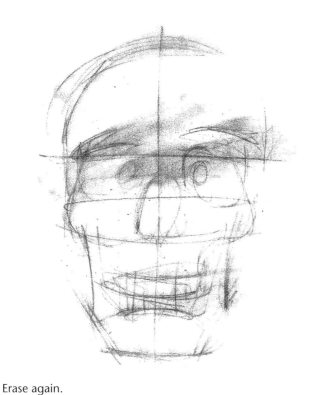

Erase again.

Give It a Stir and Let It Simmer

This time, using a finer, more disciplined line and a more analytical eye, begin to clarify the actual particular forms of the skull. Allow the rhythm of the drawing to reflect this more considered approach.

Reduce the process of drawing and erasure to the specific areas that you are working on. Because you have previously established a sound and ordered infrastructure, your energies and attention can be directed towards the development of areas of the drawing that would normally be neglected if there were any anxieties about the overall integrity of the drawing.

The drawing should now have reached a stage where there is a reasonable working likeness that could be acceptable as an accomplished study, although it is actually now in a state to be taken a step further. The next stage is concerned with the actual quality of the line.

Reach again for the eraser and give it another stir.

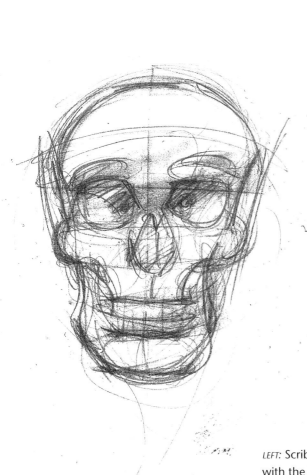

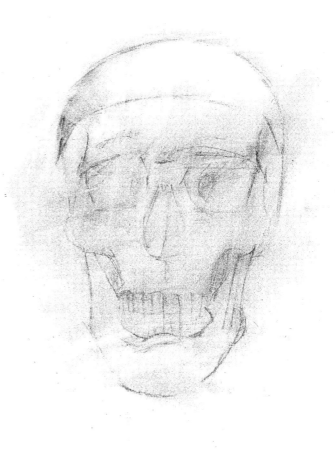

ABOVE: Erase again.

LEFT: Scribble again, although now with the benefit of guiding lines.

25

Now, with the opportunity to use a more decisive line and to explore the dynamics of the form, begin to refine the under-drawing with an assured, fluid line. Do not resort to a line that is slow, tentative and tidy. Keep in mind that 'more is less'.

Attempt to interpret the skull's structure by feeling the tensions between the shapes. Also, try to understand how you can liberate the unique properties of the thing being drawn independently from what it actually is: for example, an axe-head is actually a beautiful form, despite its function.

At this stage the drawing can be taken, if necessary, towards a further development where the sculptural aspects of the form are realized with the application of shading. It has evolved from being a basic depiction, and has progressed towards the stage where a drawing becomes expressive.

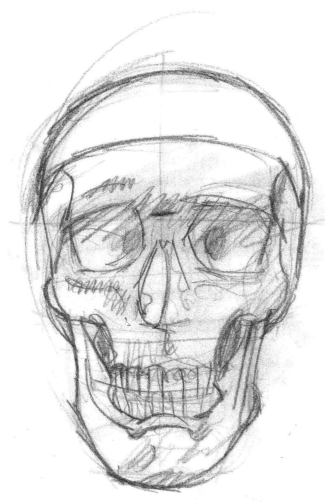

ABOVE: By now eye and hand co-ordination should be more at ease and increasing in confidence with the particular properties of the drawing medium itself. Now you can begin to realize and exploit, in a considered manner, the significant lines and forms.

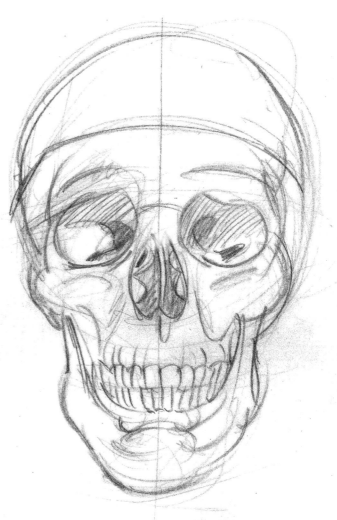

RIGHT: Concentrate on the rhythm within the subject, but beware of slipping into stylization. 'Feeling' a response to the nature of the lines will assist and develop the innate qualities of the drawing. The multiple under-drawing should now prove to be an effective and significant infrastructure to the final drawing.

Adding the Garnish

Having looked at the essential sequences of a drawing there is no real need, at this point, to move forward until through practice they become familiar and understood.

In the male skull, notice the structural differences around the brow and the breadth of the lower jaw in comparison with the female skull. The thin jaw of the child's skull is also a characteristic of an elderly skull.

RIGHT: Even though this functions as an informative drawing in this development, it can be seen how the poetry of the previous study has been reduced due to over-analysis and has also led to the shape of the left hand orb being 'tidied up'.

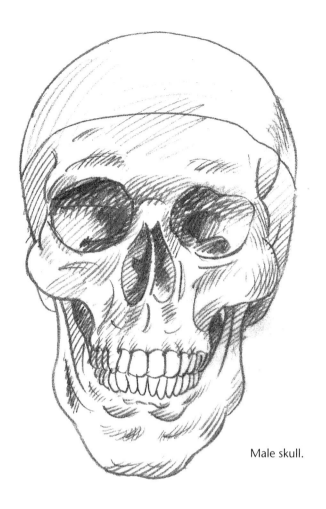

Male skull.

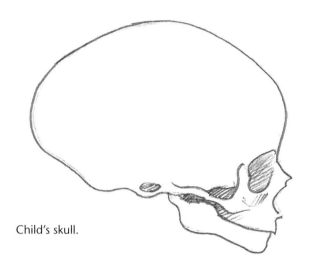

Child's skull.

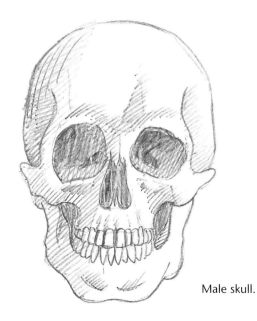

Male skull.

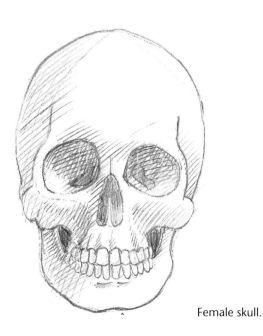

Female skull.

The Basic Grammar of the Face

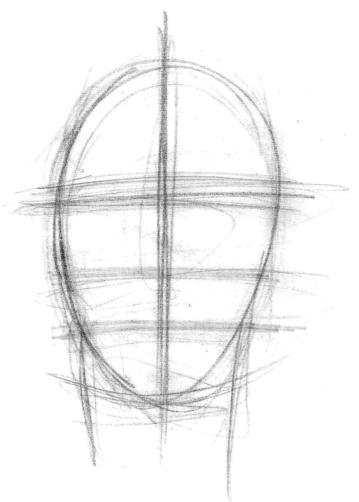

BELOW:

2. Rub it gently out so that the initial lines become guidelines. Don't be concerned about making your pristine paper grubby: just remember that you are out of control, you are floundering about. If you are not, I suggest that you take up photography.

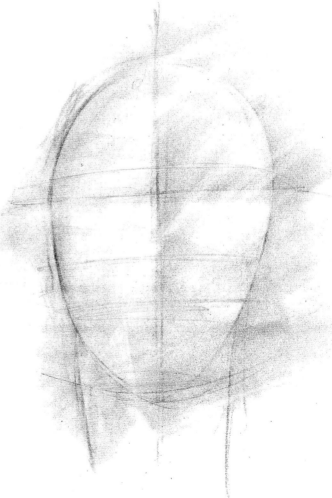

ABOVE:

1. Begin with the oval, then block in the eye and nose lines, and rough in the lines of the bottom of the nose and the centre of the mouth.

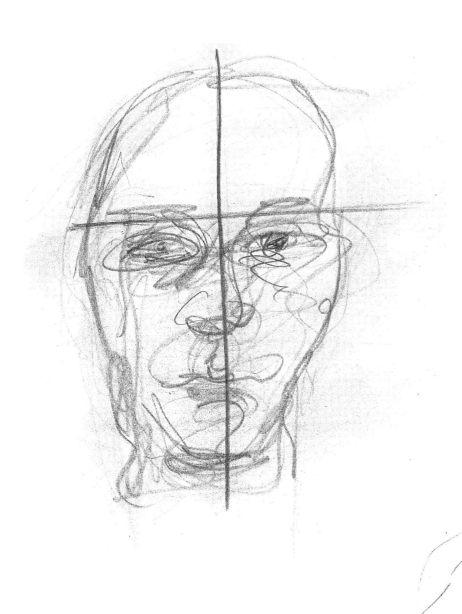

3. As with the skull, begin to scribble your way towards some understanding and establish the eyebrow line and nose line.
 Gently erase.

RIGHT:

4. Now use the erased lines and the eyebrow and nose lines to establish the position of the left eyebrow and eye.

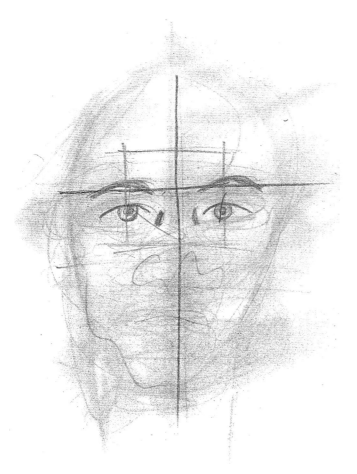

LEFT:

5. Box in the rough position of the right-hand eye. (More specific instructions about developing the eyes are to be found further on in Chapter 4.)

RIGHT:

6. Once the eyes are in position the basic form of the face is established by proceeding in this order:

A) The top of the nostril.

B) Establishing, approximately, the bottom of the nose line…

C) …and then the centre of the mouth line…

D) …followed by the beginning of the chin.

E) Down to the bottom of the chin.

F) Return to the eyebrow line to begin the next stage.

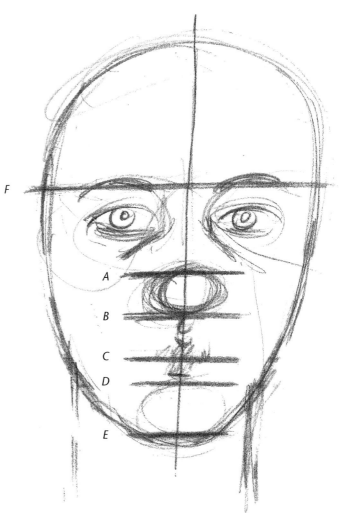

7. Gently erase the drawing again.

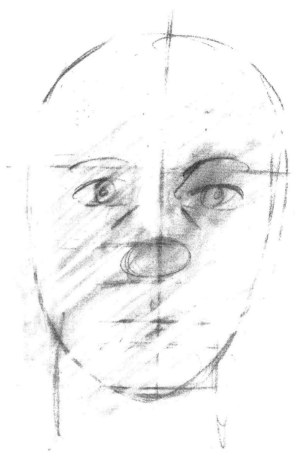

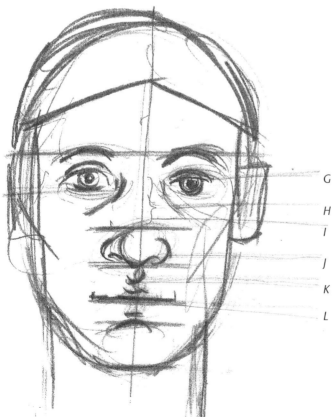

G

H

I

J

K

L

LEFT:

8. Having now established the general structure of the face, proceed to work towards the particular dimensions and distances between the features.

G) Block in eyes and the shape of the top eyelid.

H) Mark the edges of the orb.

I) Measure down to top of the nostrils.

J) Position the end of the nose.

K) Mark in the filtrum and use it to move down to the top lip.

L) Gently erase the drawing and use the underdrawing as a guide for the next stage.

9. Begin to respond more subjectively and intimately: following the same order of procedure you can now introduce more specific form to the features, and define the shape of the face and internal forms such as the cheekbones (M) and then the ears (N), which are usually found between the top of the eye and the tip of the nose.

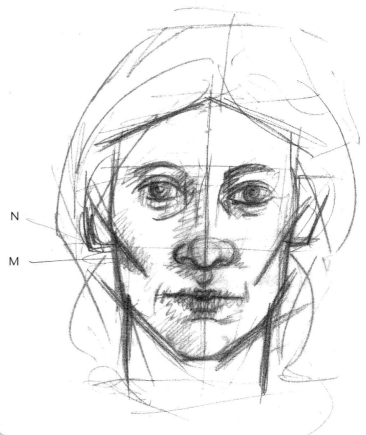

10. Gently erase superfluous lines and then re-introduce the essential ones. Then, using these, reassess and develop the drawing with more particular and decisive lines.

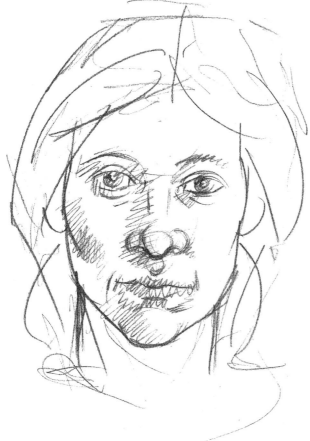

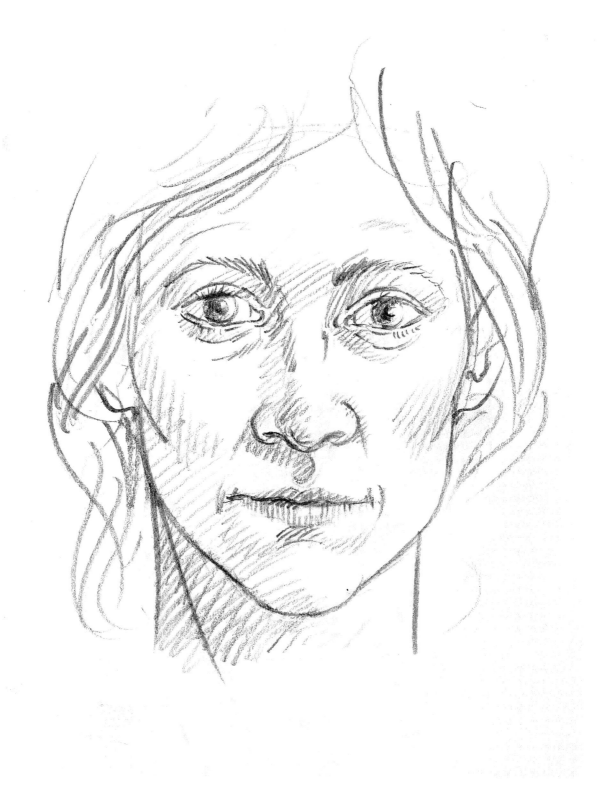

11. At this stage modelling the features with shading can begin. A drawing finished at this level should be considered to be a platform for further developments. Now find a suitable pavement to set up and practise on! Note that eyes are usually irregular in their shape and position, so try to resist 'tidying them up'.

Youthful Variations

It would probably be useful at this stage to be aware of how the proportions of the head are different in children and young people: regardless of age, the forehead takes up half the head. Notice that the quality of the line is softer and the shading is gentler.

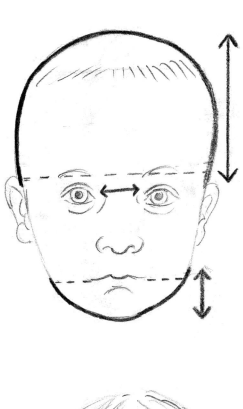

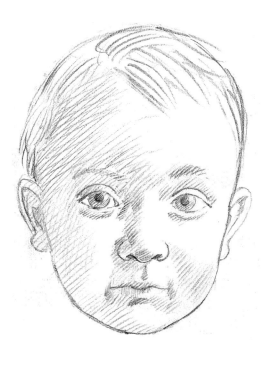

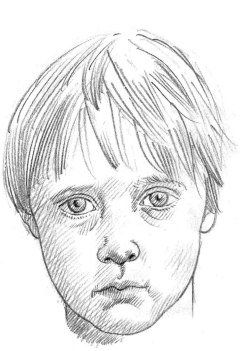

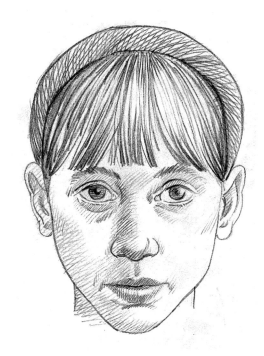

THE ADVANCED PORTRAIT

Having reached the stage where you are familiar with the basic grammar of the face, you should now have the confidence to learn its language. Once the drawing has been brought to a level of completion as in, for example, that on page 33, we can now examine each stage and each area in more detail. Therefore we shall begin with the source of it all.

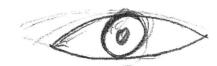

The Eye

Beginning with the left eye and using the nose line as a dividing line, create a box with roughly equal sides to establish the approximate position of the right eye. The correct positions can be adjusted later as the portrait develops. Specific details regarding the placing of the eyes:

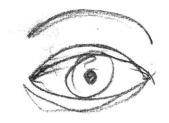

1. Starting at Line 1, move from the eye to the beginning of the tear duct at Line 2.
2. Then move from the tear duct to the edge of the orb at Line 3.
3. Next move to the nose line at Line 4 and then reverse the procedure to establish the other eye.

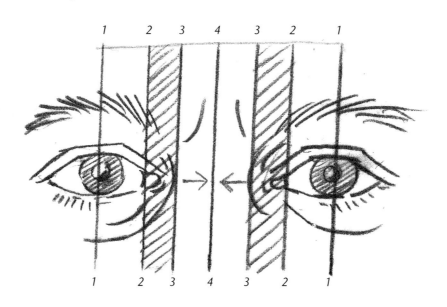

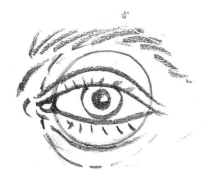

Only a small area of the eye is visible. The rest of the eyeball sits within the bone 'circle' of the orb, covered by the eyelids. It is sometimes necessary to remember this because there is a tendency to portray eyes as almond-shaped slits stuck on the skin either side of the nose.

Note that when the eye is turned the pupil becomes an ellipse and the retina alters its position due to it being below the surface of the eye.

The eyeball, the source of all intimacy and concern, is the one surface of the face that cannot be casually touched with gentleness except when drawn, where its elusive and pervasive qualities can be fixed by the sharp point of a pencil.

The movement of the eyelid over the eye, the degree to which the lids partially or entirely eclipse the retina, affects the countenance of the face just as a cloud passing over the sun transforms the mood of a landscape.

Be aware that when drawing from the model, the sitter's eyes will be responding to an unfamiliar situation. They will probably be staring fixed into space, focusing on things that would not normally be given a second glance; or they may reflect the sitter's mood of concentration or boredom. The sitter will also be acutely aware of their appearance and your scrutiny of it, let alone what you efforts will look like.

Returning to the fact of being aware of your own presence, remember that it is likely that the sitter is just as intensely observing you. Therefore, do not distract or irritate them by, for example, teasing the tip of your nose with your tongue, yapping gum or, especially with false teeth, sucking boiled sweets. Try to inspire confidence.

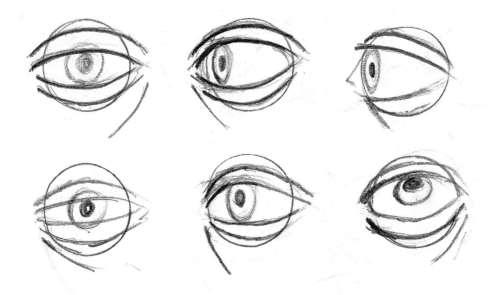

Pay particular attention to the shape of the upper eyelid and the definition beneath the eye. Also note the position and texture of the eyebrows; familiarize yourself with the patterns and shapes to begin with, and then superimpose the actual curves.

In normal circumstances, eyes are usually fleetingly glimpsed and are constantly mobile. When they are still, and are seen through being drawn, they are no longer isolated areas of activity of expression, but become seen as an integral part of the face.

Certain characteristics will be noticed. In capturing the nuances within the form of the eyes you are almost half-way there to capturing a likeness. Pavement portrait artists are aware of this and know that when persuading the punters to agree with their 'likeness' it's usually the response 'Oh, you've got my eyes' that sells the drawing, leaving the rest of the face to be argued about when unpacked back home.

When it remains true to its actual purpose, which is to visually communicate what is essentially silent knowledge in the most efficient and practical way, drawing is one of the great levellers.

It has been said that anyone who has attended Oxford University will tell you within the first twenty minutes of meeting them and will continue to do so every fifteen minutes. It is also, probably, true that despite their degree within five minutes of drawing an eye they will produce something like the examples here, and will continue to do so ad infinitum and probably no differently than would the medieval labourer who built the dreaming spires.

Drawing is not simply about capturing a likeness; it is the by-product of highly sophisticated thought processes that can only be realized and developed through continuous focused exercise. The study of military history, which deals with the controlling of capricious convergent and divergent forces towards an uncertain aim, is probably more useful in understanding the creative process than that of any art historian or critic.

As understanding emerges, so too does the desire to evolve methods of depiction to clarify and realize these insights. The use of symbols, pictograms and the two-dimensional becomes inadequate and constrictive when attempting to expand into and explore revealed territories. Visually creative disciplines – from painting through to choreography and cinematography – not only have their roots in the act of drawing but have been liberated through, for example, the historical solving of the problem of perspective; they in their turn have then expanded the grammar of human expression. These concerns should not be considered by the beginner to belong to a distant esoteric realm of experience, but should be seen as an irrevocable part of their own personal development and awareness.

Unfortunately there is still often heard the glib adage that 'An artist is not a special kind of person, but every person is a special kind of artist.' This not only denigrates the aspirations and the hard-won achievements of both the vocational artist and the serious student, but its spurious sentiment is blatantly absurd if you substitute the word 'gas fitter' for 'artist'.

The Eye Itself

The distance between each eye, like anything else concerning the human form, should not be taken for granted. This is why measuring using, as a guide, what you see before you rather than what you imagine is essential in solving difficulties. The height of each eye in relation to the other, and the angle at which they sit – whether up to or down towards the nose line – must be noted carefully.

The eyelids usually obscure the upper and lower parts of the pupil. Sometimes the upper lid will cover most of the top half of the retina. Sometimes the skin above the upper lid will cover the lid itself, leaving just a rim of eyelashes. The creases (crowfeet) at the corner of the eyes are to be found to some degree in all ages. The tear duct also acts as a small but convenient connection of the eyeball to the surrounding eye, as well as a fixed point of reference to measure from.

A speck of light in the pupil – usually, that last eagerly awaited dramatic finishing touch that brings the face to life – is not always present. Some eyes appear not to emit light, some will appear to look inwards and there are some that may set you thinking about the nearest exit.

Note that children's eyes are wider and clearer, and have fewer surrounding definitions.

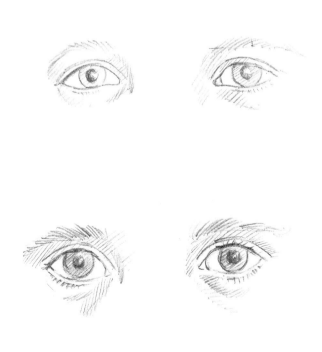

Children's eyes are larger, simpler and brighter.

Be aware of the subtle angle of the eyes and eyelids and the distance between the eyes.

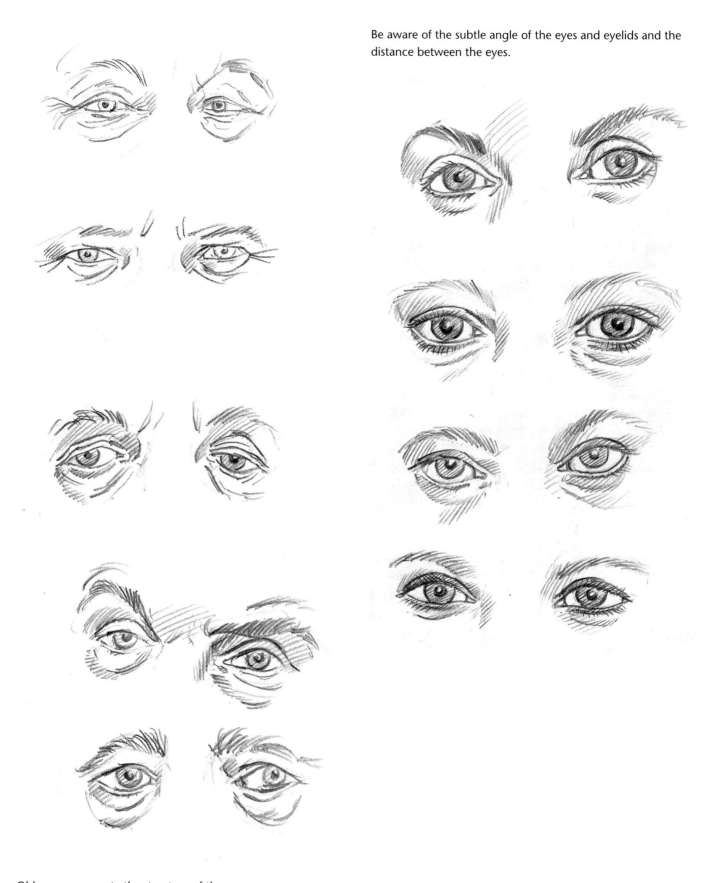

Old eyes exaggerate the structure of the eye.

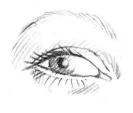
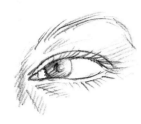

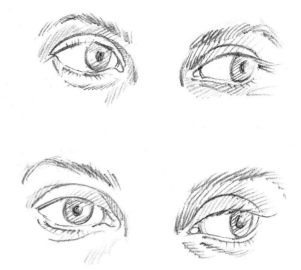

Compare these Asiatic eyes with the Caucasian examples below.

BELOW: Notice how the eyebrows and the structural lines tighten up, and extra lines appear, when the eyes are concerned.

In a brief moment the shape and demeanour of the eyes can alter. Therefore, when drawing the eyes in a portrait, choose the subject's most frequent and typical expression to represent them.

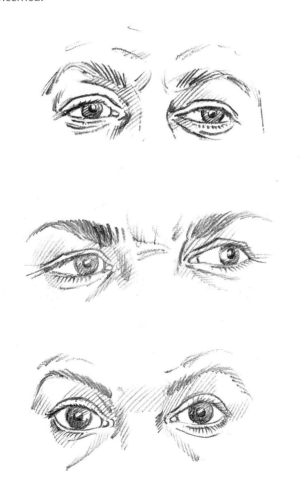

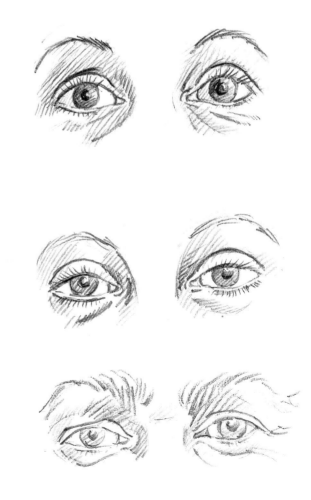

RIGHT: Some faces have naturally raised eyebrows, which will raise even further when seeing your efforts.

Drawing the Eye

Draw the eye using the same process as has been used in drawing the skull and face, which is 1. generalize, 2. erase, 3. particularize.

1. Block in.

2. Establish the centre of the eye and work outwards, generalizing the basic structure of the eye

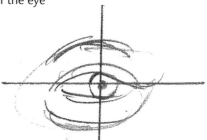

3. Erase

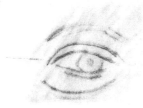

4. Particularize the forms.

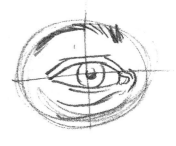

5. Introduce structural shading

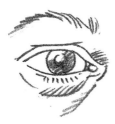

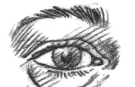

6. Add further shading as required.

The Parts of the Eye

The Orb

The surrounding rim and the upper ridge of the orb (that forms the brow), and how and where they are present around the eye, are very important. For example, the brow juts forward beyond the lower edge, casts a shadow over the upper part of the eye and helps form the edge of the face, especially when seen in three-quarter profile. The lower edge, according to its degree of prominence, can suggest age and psychological experience. It is also an invaluable starting-off point to measure from to establish the length of the nose and the edge of the temple.

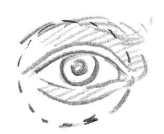

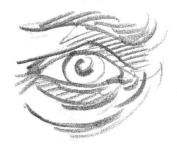

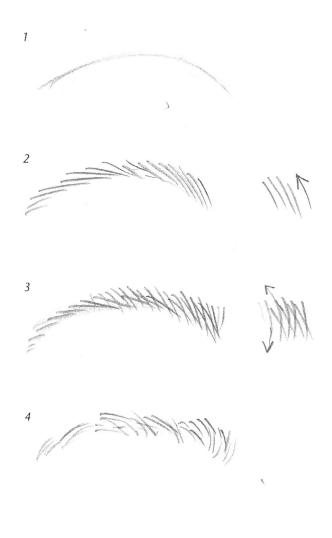

The Eyebrow

We have seen earlier the significant role that the eyebrow line plays in the construction of the face. The eyebrows themselves can, when observed more than usual, appear to be faintly absurd, and yet their effect on the character of the face can be quietly dramatic. Their form and the space, or lack of space, between them must be accurately taken into account. Take particular note of the direction that the hair of the eyebrow grows: sometimes they can be fixed in a position of permanent surprise or brooding menace, despite what the rest of the face communicates. Be aware that some eyebrows, when relaxed, are naturally raised or lowered.

Always begin the eyebrows by lightly and tentatively establishing their direction, shape and width before defining them over-enthusiastically.

The Eyelashes

The lashes must not be stuck on in a perfunctory manner. Their tone, length and density play a significant part in framing the eyeball and its visual effect. For example, lashes can sometimes be thicker towards the outside corner of the lids, thereby resulting in an intensifying of the gaze.

Pay particular attention to the shape of the cartilage on the bridge of the nose, below the space between the eyes. It usually acts as a funnel for the potency of the eyes down towards the mouth.

Try to keep a line of light between the pupil and the lower lashes, otherwise the eye can become over-emphasized and will lose its vitality.

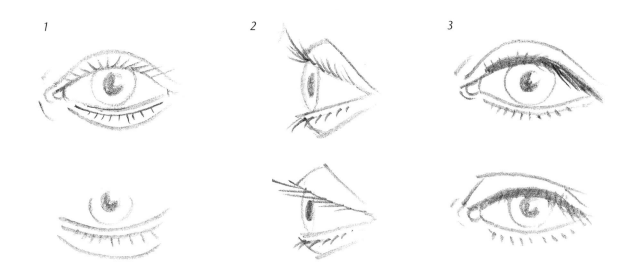

The Angle of the Eye

When looking at the drawings in this book, try to notice how the angle at which the eye is seen will inevitably suggest some sort of mood. For example, the eye seen in profile will possess an air of reflection and stillness. When seen from above, a feeling of melancholy and tenderness. Seen from a three-quarter angle, the face appears alert and prepared, and from below there is a sense of vulnerability and nobility. When the eyes are tilted to one side they can capture a coyness, sending out a message of pre-emptive contemplation. Eyes looking straight ahead are probably the most difficult to render because of their potentially confrontational aspect and possible sexually challenging directness.

A three-quarter angle as seen on the right is usually problematic for beginners, because it is one of the first instances encountered where what you actually see objectively has to be interpreted abstractly in order to arrive at some degree of accuracy. Try to imagine the furthest eye behind the nose as if it were a shape actually attached to the edge of the nose, rather than seen as an independent feature.

When drawing always try to keep the 'feeling' of the actual shape that you are drawing in the back of your mind. For example, an eye is 'ball-ish': this should help create an affinity with the shape and how it affects and relates to other shapes or forms that are attached to it.

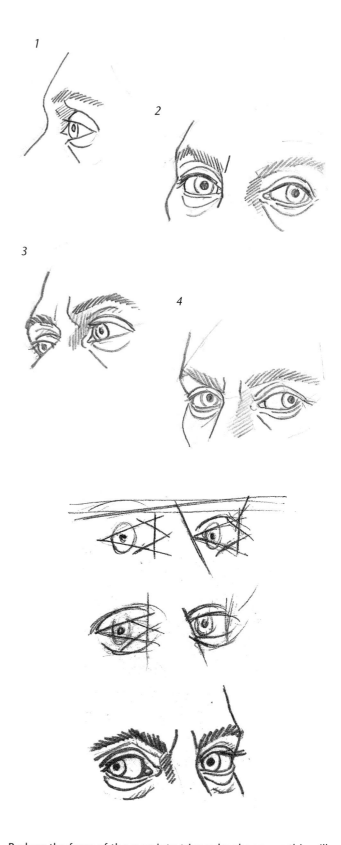

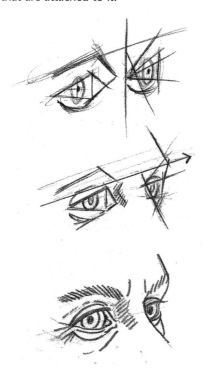

Look very carefully at the angle of the eyebrow line, because it is not necessarily positioned horizontally.

Reduce the form of the eyes into triangular shapes, as this will help to define the actual shape of the eyes and will also help to prevent getting lost amongst the curves when attempting to correct the position of both eyes together.

The Secret of Art Revealed

Out of this symbol (A) you can create anything you want. The arrow is the direction of basic shading. Out of the horizontal and vertical lines and the angle of the arrow a circle can be created, then a sphere, then an eyeball and then …

The secret of art is in the ability to see the curve in the angle. So there it is.

Analogy is very useful in comprehending the relationships within and between the various components of subject. Investing the act of drawing with a sense of narrative will not only prevent the drawing from becoming cerebral and diagrammatical, but will allow for personality to infuse the character of the work. Imagine when drawing an eyelid that you are peeling back a piece of cling film from a billiard ball.

Drawing Spectacles

When drawing glasses, do not regard them as additions to the face because if they are continuously worn by the sitter they will, in effect, have become an integral part of their likeness.

Regardless of what shape the glasses are, block them in using squares or rectangles to establish scale and the space that they occupy.

A

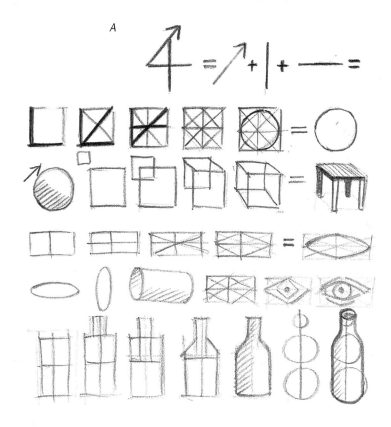

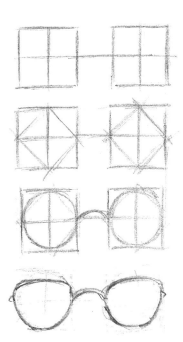

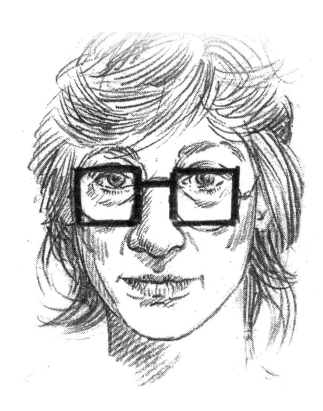

Key Points to Drawing Spectacles

TOP LEFT AND RIGHT: 1) Use the top edge of the upper eyelid as a guide for placing the height of the lenses.

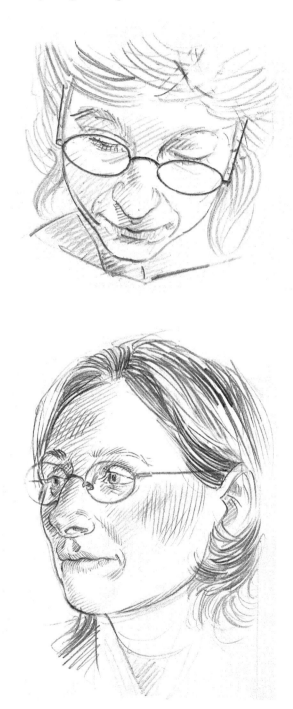

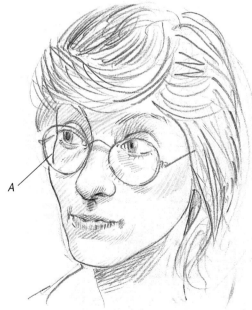

2) Note whether the eyes are magnified or distorted and, if so, draw as seen. Also note that in a three-quarter profile the lenses can sometimes distort the outside contour of the edge of the face (A).

3) Do not add reflections of light with the eraser. Being able to see the form of the eyes is more important and, of course, more interesting; it is also a forgone conclusion that they are made of glass and, as with any other aspect of portraiture, superfluous attention to detail becomes a distraction.

The Nose

Damn the nose. There's no end to it.
 Gainsborough, whilst painting Mrs Siddons

From the point of the tear duct or the corner edge of the orb, measure down to the top of the nostril. This particular area, if not controlled, has a tendency to become over-extended. It is easier to assess the correct distance by shading lightly down to the nostril, rather than using line. You are then in effect finding the distance by objectively observing the tone as it proceeds, rather than indirectly by using the subjective judgement of the mind in control of a drawn line.

This ability to change from the objective to the subjective use of line is an important factor in drawing. The combination of the two attitudes, describing the linear and describing the mass within a drawing, is like knowing when to change gear in a car, or when to use a knife.

Note that when shading the nose, for the sake of simplicity, it is only necessary to shade one half of it and to emphasize, to whatever degree, the bridge or cartilage. Otherwise there is a tendency for people to notice the absence of the elastic keeping it in place.

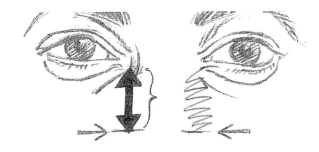

Measure down from the corner of the orb or tear duct to the top of the nostril. Use shading to establish the distance.

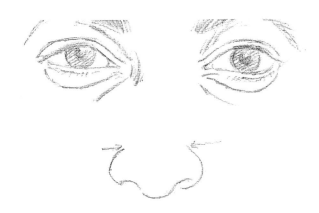

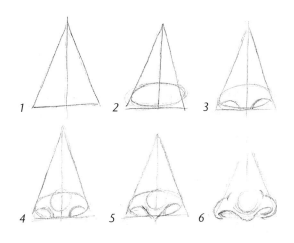

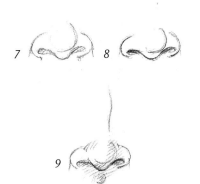

1. Establish the nose with a triangle. Draw in a central line to measure against.

2. Establish the area of the nostrils and the end of the nose with an oval.

3. Block in the appropriate position of the nostril holes.

1. The end of the nose can be broken down into an oval.

2. Block in a circle within the centre of the oval to represent the end of the nose, then add two semi-ovals either side to establish the nostrils.

3. Adjust the centre circle to the angle of the nose: are you looking at slightly above or below the nose?

4. Introduce a smaller circle to represent the tip of the nose.

5. Develop the form.

6. Erase the underdrawing and finalise with shading.

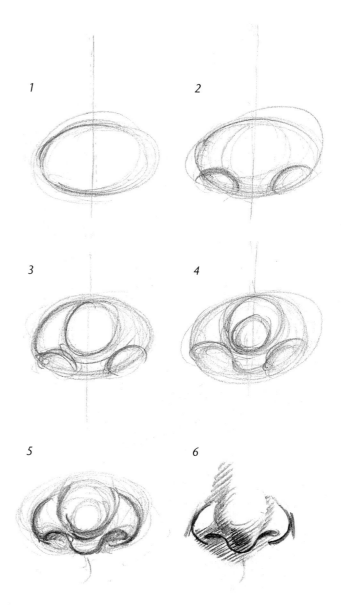

Those beginners who feel, whilst they concentrate on the serious business of drawing, that studying basic anatomy is a chore to be dealt with later, inevitably encounter their nemesis in the shape of the nostrils. All ambitions take a tumble at the end of a nose. This complex of sculptural convolutions is actually only daunting to the undisciplined eye, so exceptional patience and the application of common sense and clarity of observation are essential. This is not an area for self-expression.

Try to see the nose not as an appendage stuck on the front of the face, but rather as a protuberance resulting from all the features of the face being pulled together. The nose in portraiture is a source of some unexpected turns of events. Its idiosyncrasies, whether it sits in harmony or in discord with the demeanour of the face, are an integral part of the character and interest of the portrait.

However, unlike in caricature where the artist's job is to capitalize on the idiosyncrasies, a commercially successful portrait painter will always find the angle from which the nose looks best and any imperfections are least noticeable.

It is obvious that in a portrait the nose can only be depicted as seen from a fixed viewpoint, whereas in the mind's eye, where it is the sum of a multitude of remembered images, it can often be thought of as very different. The nose's capacity for dramatic changes in appearance with just a slight turn of the head, combined with the tendency to view it independently from the rest of the face rather than as an integral part, can result in disaster.

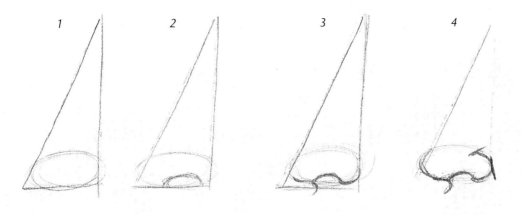

Use a triangle to establish the nose seen from the side, and proceed with the same sequence as before.

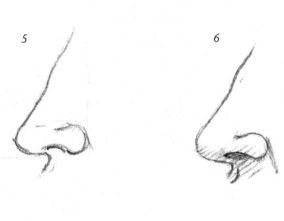

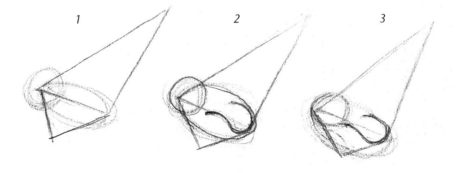

1. For the nose seen from below, use two angled triangles as the infrastructure, the smaller triangle represents the base of the nose.

2, 3. Add an oval and circle as before.

4, 5. Use the outside edge of the smaller triangle as a guide for placing the far nostril.

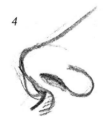

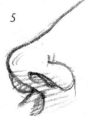

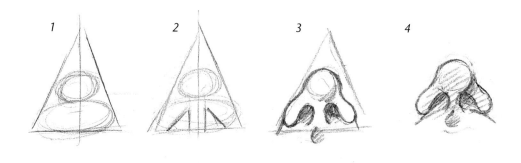

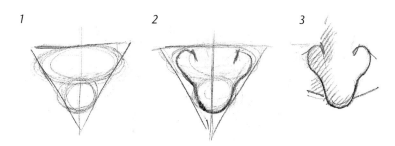

ABOVE AND LEFT: For the nose seen from below and above, rearrange the position of the oval and circle accordingly.

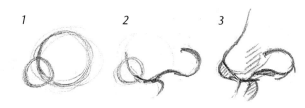

LEFT: Placing the far nostril on the nose seen at a three-quarter angle. The large circle represents the end of the nose and the smaller circle is used as a guide to positioning and assessing how much of the far nostril is visible.

Shading the Nose

2, 3. For normal lighting conditions, shade only one side of the nose, using upwardly slanting strokes.

4. Use the circle to help structure the end of the nose.

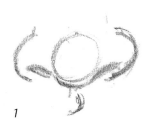

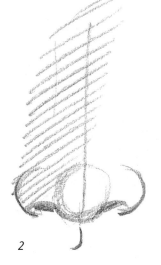

The Mouth

A portrait is a picture where there's something not quite right about the mouth.

attributed to John Singer Sargent

Most beginners tend to opt for the stuck-on, shiny, plastic, Mr Potato-Head style of mouth. In drawing terms there are two specific areas of texture on a portrait: the hair and the mouth. Each being a source of intimacy, their treatment should require particular attention and sensitivity; therefore, capturing the subtle undulations and contours should be an engaging challenge.

The area above the top lip and beneath the nose is not flat; it is shaped like a canopy (look at the protrusion of the teeth in a skull). Special attention must be given to the naso-labial furrow (there's a word to alarm your Let's-Paint-for-Pleasure tutor!) or the filtrum, which is the furrow that connects the upper lip to the base of the nose and which hopefully your model is not forever wiping. It is deceptively important because it is sometimes longer or shorter than assumed. Also, its prominence can have a profound affect on the character of the face, due to its affect on the distance between the eye and the mouth, which are both sources of psychological assessment.

Although portrait painting is one of the few occasions where you can politely ask someone to shut their mouth, lips do not necessarily have to be closed. Some mouths are naturally sensually or gormlessly parted.

Using the same method as on page 45 to establish the distance between the eye and nostril, establish the position of the filtrum and the centre of the top lip.

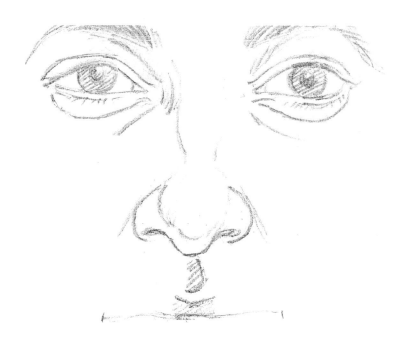

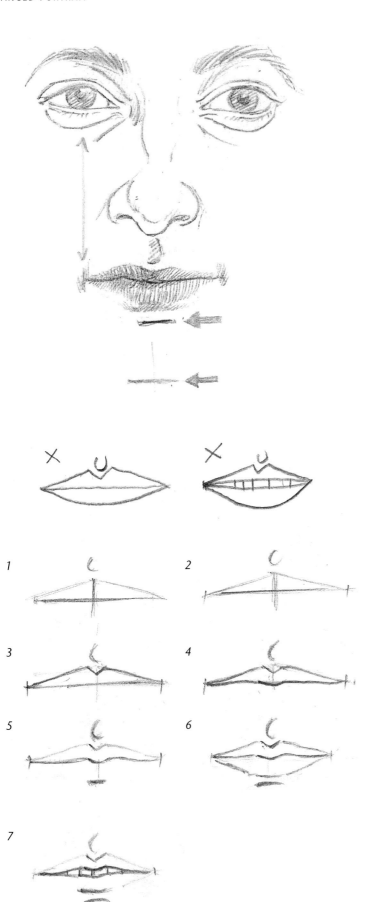

Draw in the centre line of the mouth; its corners should align with the centre of the eyes. Then block in the lips and introduce the indentation beneath the lower lip where the chin begins to protrude, and an approximate indication of the end of the chin.

Proceed to structure the mouth using the same principles as were used for the eye.

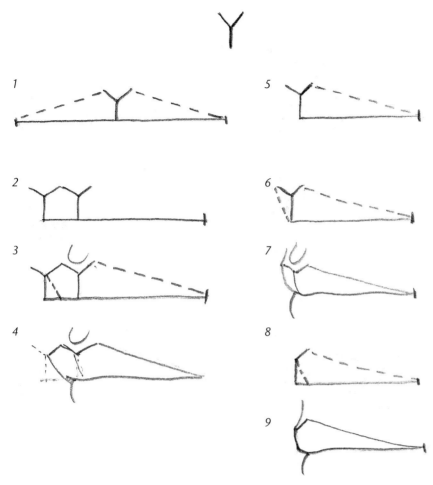

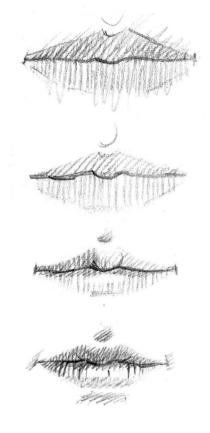

By moving a 'Y' shape along the centre line of the mouth, you can arrive at the basic angles of the lips.

Lightly draw in the contours of the lips and shade over them (not up to them); then shape the edges with the eraser. This not only gives them a sensuality, but also allows them to merge with the surrounding skin.

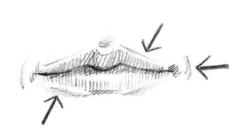

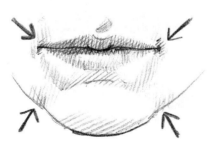

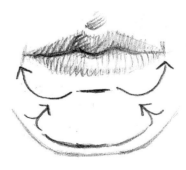

ABOVE:

A) Some lips, especially female, have a gentle, occasionally prominent, protruding rim around the outer edges of the lips. These must not be ignored and must be subtly rendered, otherwise they tend to look like pencil-moustaches.

ABOVE:

B) The indentations at the corners of the mouth and at either side of the chin are small but essential.

ABOVE:

C) The structure of the shading beneath the mouth should be carefully considered: it acts as a support for the mouth and forms the top and front of the jaw, and the borders of the chin. Examine the patterns because they apply to all forms of jaw.

The tubercle is the bit on the centre of the upper lip that envelopes the top of your pencil when you are pondering on what got you in this mess. Its size and protuberance affects, as you have probably guessed, the sensuality of the mouth, especially in conjunction with the degrees of the flexibility and volume of the lower lip.

The lines at the corners of the mouth, like the crow's feet of the eyes, are small, quirky lines that can erupt into a smile or twist into a sneer. Unfortunately their length and depth, if given too heavy a treatment, can lend an expression of sourness or ageing, as well as giving the face the look of a ventriloquist's dummy.

1) There is a shadow beneath the top lip.

2) The top is darker.

3) The lower lip is lightly shaded.

4) One side is darkened.

5) Light is erased onto the top of the lower lip beneath the shadow. Any creases in the lips can then be added.

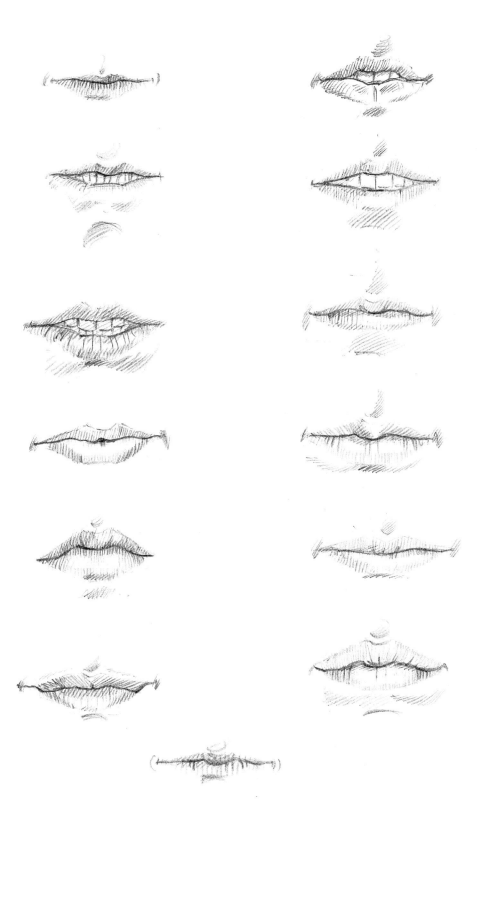

LEFT: Notice how some lips are naturally parted; also, the size of the upper and lower lip can interchange. The texture of the lip can be regulated by the pressure and the degree of sharpness of the pencil.

BELOW: A helpful hint is that the corners of the mouth are usually aligned directly beneath the centres of the eyes. When the corners move away from these points, however slightly, with the corresponding movement of the eyes the face becomes animated with all degrees of expression.

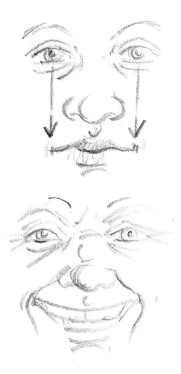

The Teeth

The teeth, as in life, can be an aesthetic problem. They are a good example of how humans can accommodate and co-exist with all manner of unfortunate things. Even when particularly prominent they are usually quite socially acceptable in the human face, but are met with alarm and squeamish fascination when seen on a chimp or an alligator. When drawing teeth, pay particular attention to their idiosyncrasies, however slight, because they contribute a significant part to the recognition of a face (as well as our bodies).

Do not treat teeth as a collection of individual pegs of enamel, but draw them as if they were gently engraved onto a single curved strip of ivory.

The Smile

Most professional portraitists will shudder at the mention of the word. To them the smile is usually the kiss of death to goodwill towards the sitter.

The dreaded words, conveyed in a tone of shy hesitation but in fact establishing an irrefutable fact, 'I see myself as a smiley sort of person. People are always forever saying it, don't you know?' One soon realizes it's more a case of being unbearably smug and insincere.

As we have seen, a portrait is a fixed accumulation of choices derived from an artificial situation where normal facial activity is dormant. The artist attempts to distil the essence of the sitter's character rather than specific traits. As a portraitist you have the benefit (and so do undertakers) of being able to meditate upon the actual nature of the face rather than the vague mercurial impressions that the majority of people witness.

Photographers are limited by the two-dimensional nature of the photographic process. Fine artists, on the other hand, should be continuously enriched by the ascending levels of physical and intellectual ability required to comprehend another human being. They should exploit the potential of the medium and the advantages of the organic development of the image.

LEFT: Note that in some smiles only the lower teeth are visible.

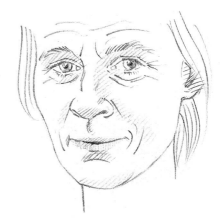

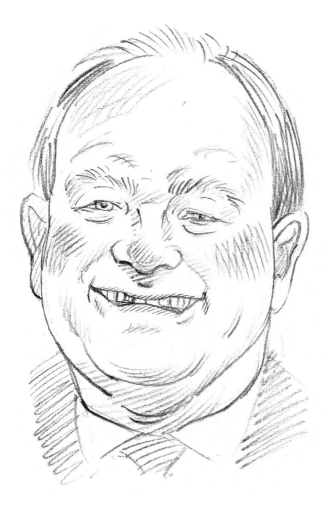

When a face shows an expression such as smiling, it is an entirely different face from that of smirking and should not be treated as the same face with minor alterations. As an example, an ellipse may be a different aspect of a circle and can be intellectually understood as such, but it is in reality an entirely different shape. There is never actually a 'definitive face', only aspects of what is essentially an abstract one. Note that the wide smile is bolstered by the angle of the head.

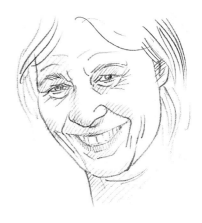

ABOVE: The general purpose studio smile. This type of smile is usually meaningless. Any meaning is usually dependent on what the subject is wearing and how its message affects the look in their eyes. This smile reflects the artificial circumstances that it is reacting to, such as a camera rather than another person. There is an unfortunate tendency to make the smiler look self-satisfied.

LEFT: Many of you at some point, either through choice or duress, will attempt to portray children and it predictably follows that they must be smiling. Keep the lines spare and light, and concentrate on and around the eyes to capture the particular quality of a child's expression. Keep the area around the mouth uncomplicated. Suggest rather than over-emphasize.

The manner in which a smiling head is drawn can also contribute to its success. A lively, suggestive style of line can help to loosen up the features so that the smile doesn't become too dominant.

This example represents a composite of elements that have been looked at regarding 'The Smile'. All the features and the expressions of the face are restrained. It is better to choose a point in an action, in this case a smile, where the act is midway between beginning and ending, thereby sustaining its potential rather than exhausting it with a full-blown grimace.

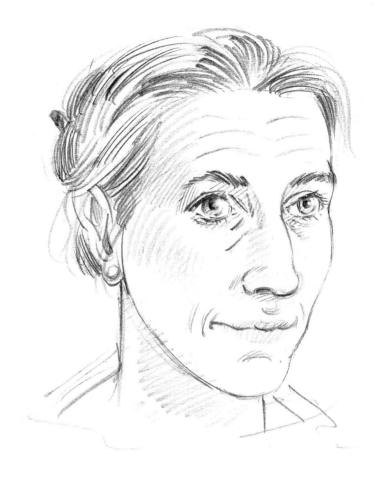

The Chin

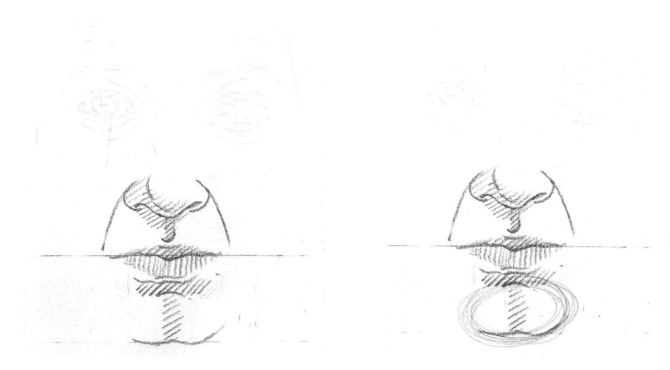

Use the shading method to move down from the entre edge of the lower lip to where the chin begins.

Adapt an oval to represent the basic form of the chin. Imagine it to be half an egg.

The Jaw and Cheekbones

Refer back to the section on the skull. The jaw is like a shelf upon which the top of the face rests. Its length and shape probably introduce the most animal-like element to the structure of the head. It can prejudice the face with assumptions of strength, elegance and weakness.

Sometimes it sits uneasy with the proportions of the rest of the face – perhaps jutting out, receding, at its point or at its sides. Regardless of its nature, the line of bone around its lower edge should be emphasized to give the head, as with a shelf, a firm base.

One of the most problematic angles to solve in drawing the head is found in the area beneath the jaw where it joins the top of the neck. It is an area where to analyse it objectively always results in the drawing looking awkward and incorrect.

It is one of those areas in drawing from the life – others being foreshortening and fingers – where you have to arrive at a compromise between what is actually there and how artifice is necessary to make it visually coherent. This can usually mean reducing and eliminating lines that are there and adding ones that aren't. It is a situation where simply drawing what you see before you proves not to be the unshakeable dictum of objective drawing.

It is where the student realizes that 'getting it to look right' not only relates to the subject before them but also, just as importantly, to the objective nature of the drawing itself. It is in this realization that the student begins to understand that art is a pragmatic undertaking, regardless of its grandeur, and that just as the line does not exist in nature and that the drawn line is actually an anomaly, it follows that the art itself exists within a world of constantly shifting values. Where one becomes, and contradicts, another. It is in this state of uncertainty that art probably comes as near as we can to interpreting a world seemingly stable in its instability.

■ Therefore suggest rather than explain.
■ Be aware that line and mass are interchangeable with each other (especially in painting).
■ Reduce and isolate seemingly complex areas into their essential components and progress from these.
■ Utilize the full range of potential of your medium, not allowing one particular method to dominate.

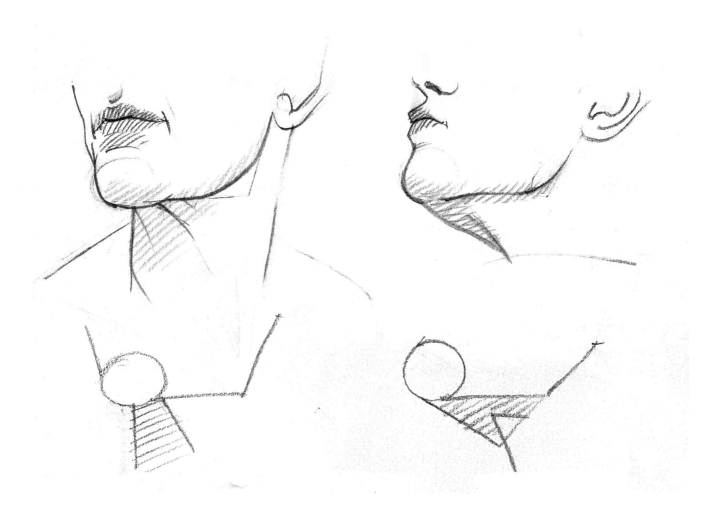

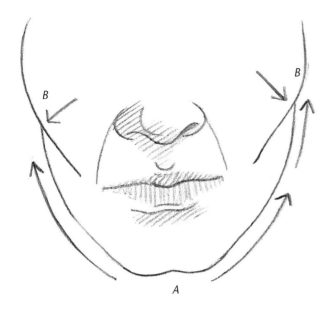

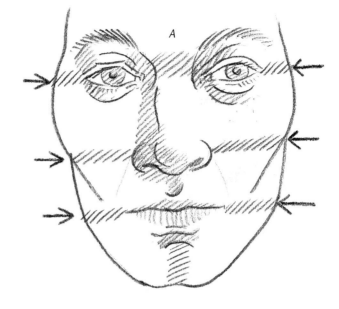

Work outwards from either side of the centre of the chin (A) upwards towards where the cheekbones intersect (B).

1. Use the corners of the mouth, nostrils and eyes as reference points to gauge the width of the jaw (arrowed).

2. Apply the same shading method as was used to establish the distance between the eye and the nostril.

3. Reinforce the shape of the chin by drawing back down from the intersection of the cheekbones.

4. Finally, introduce the degree of shading at the bridge of the nose (A). This area not only gives the impression of projecting the nose forward, but also optically connects the eyes together.

The Ear

Knock! Knock!
Who's there?
Pardon?

Gauguin and Van Gogh in Arles

The ears usually occupy an area between above the eye and below the nostril. The ear, at first sight, is a labyrinth of irrational folds and tucks. Being slightly ridiculous, they are probably placed out of the way on the side of the head because if they were on the front of the forehead I doubt we would have procreated so eagerly, and also I imagine that God had to hold onto something while he fiddled around with the teeth.

When attempting to tackle an ear, just as in talking to one, it's easier to get straight to the point and elaborate from there, the

point being in this case the ear-hole. Unlike in a maze, you find your way out of the centre to arrive at the earlobe.

Obviously, the ear is ideal for supporting the hair, and if possible always try to draw it exposed because it is an invaluable way of measuring the length of the jaw and the width of the head. To find the approximate position of the ear, follow the contour of the edge of hairline starting above the end of the eyebrow, towards the top of the ear. The ear usually then extends down to a line drawn across from the centre of the lips.

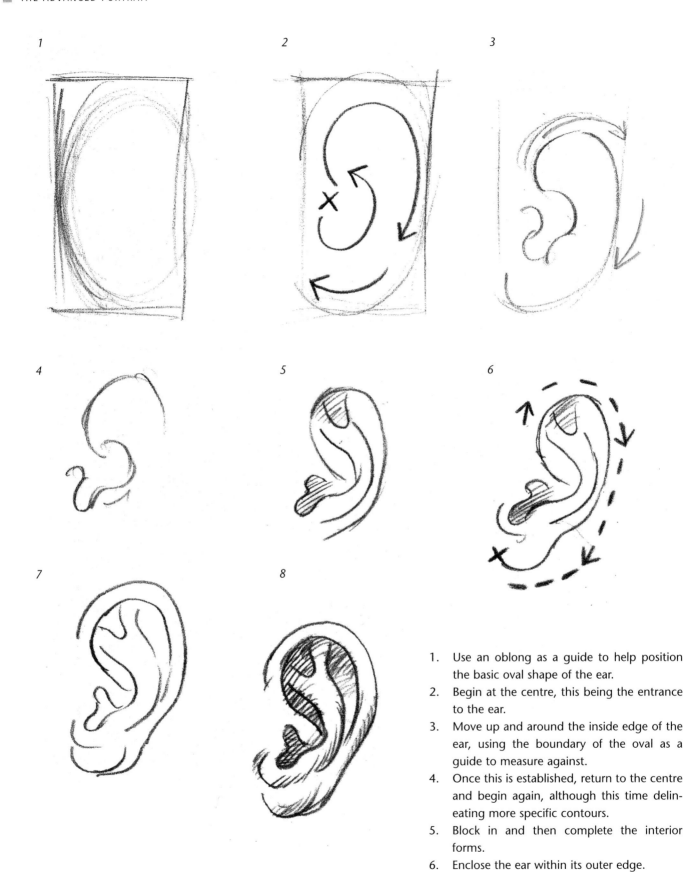

1 *2* *3*

4 *5* *6*

7 *8*

1. Use an oblong as a guide to help position the basic oval shape of the ear.
2. Begin at the centre, this being the entrance to the ear.
3. Move up and around the inside edge of the ear, using the boundary of the oval as a guide to measure against.
4. Once this is established, return to the centre and begin again, although this time delineating more specific contours.
5. Block in and then complete the interior forms.
6. Enclose the ear within its outer edge.
7. Complete the outline of the ear's form.
8. Fill in the basic areas with simple shading.

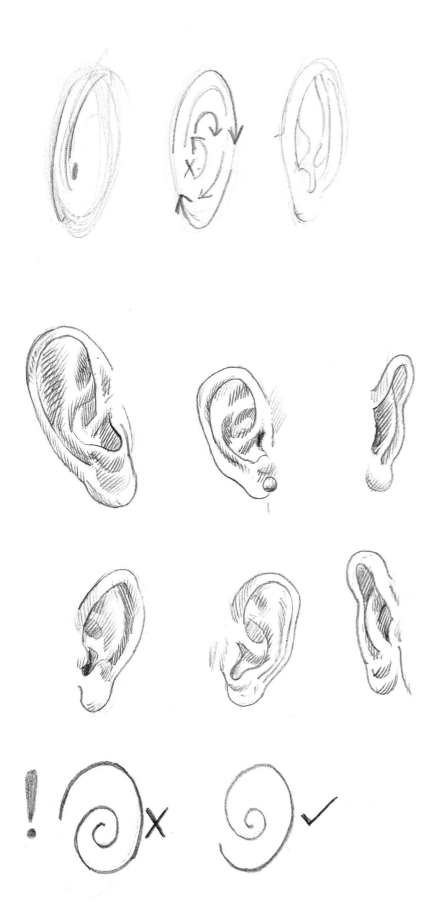

The ear is the perfect subject on which to practise and understand the essential ability to ignore what is *thought* to be seen and to see things as they *actually* are. Also, they are great confidence-boosters when it is realized that a seemingly complex object can be easily broken down into its basic structure and understood, and that the same methods can be applied elsewhere in the face.

The Jaw and Face Seen from Below

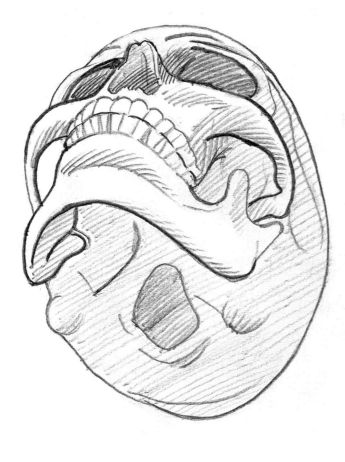

Note how each cheekbone is differently depicted. The left-hand side is formed by shading and the right-hand side by line. Refer to the skulls to understand the structure of the cheekbones.

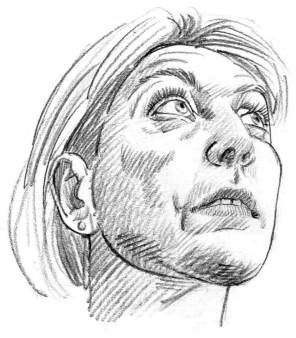

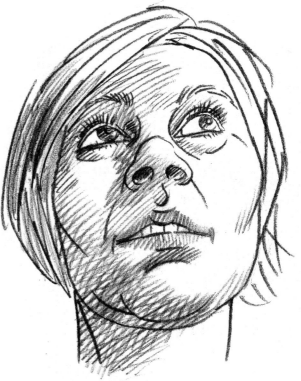

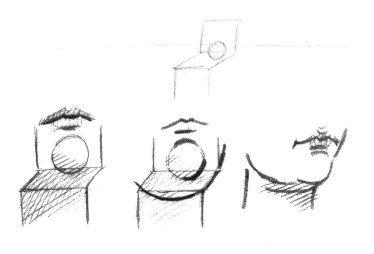

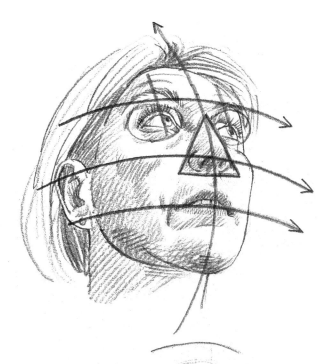

When seen from beneath, reduce the basic form of the chin to that of a seat seen from behind with a sphere set into its lower edge.

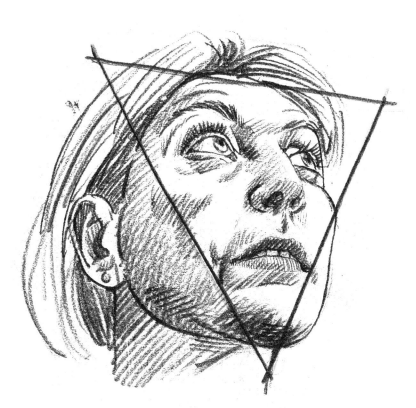

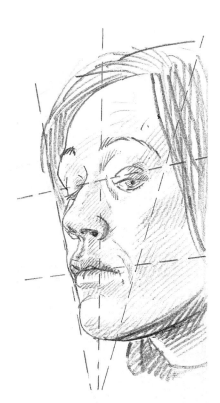

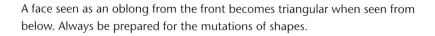

A face seen as an oblong from the front becomes triangular when seen from below. Always be prepared for the mutations of shapes.

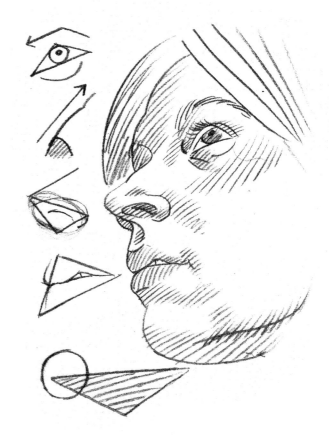

ABOVE: At this angle the nose always appears to be longer and thinner, due to the area beneath the brow being exposed. Note how the neck leans forward. The neck in repose usually projects beyond the chest, and is rarely upright as is commonly assumed.

ABOVE RIGHT: See how the odd angles of the features can be achieved by reducing them initially into basic shapes.

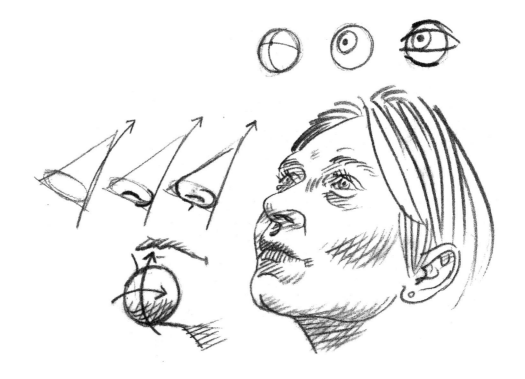

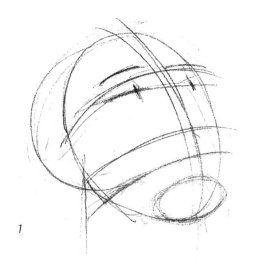

1

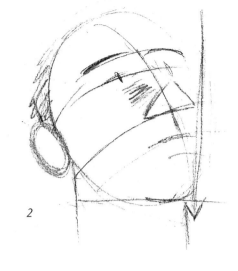

2

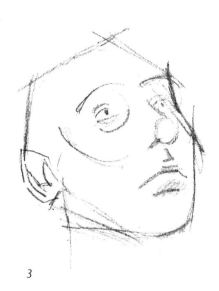

3

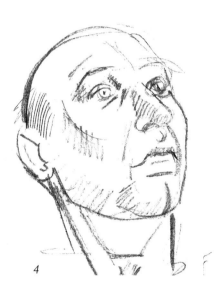

4

1. Block in the general angle and form using a tilted egg shape. Establish the essential guidelines of the face and an oval for the chin.

2. Pay particular attention to the length of the forehead, which will be shorter than the distance between the base of the nose and the tip of the chin.

3, 4, 5. Proceed with the normal sequence, as seen before.

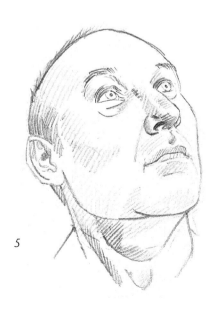

5

The Hair

There is an extraordinary compulsion amongst beginners to treat certain areas of the body with unbridled expression or carelessness. Fortunately, in this instance we are only dealing with the head.

It seems that beginners, having experienced the ordeal of completing a face, almost inevitably take out their frustrations on the hair, making the sitter look like they either are wearing a flea-ridden hat or have just fended off an attack by a bat colony. The wealth of subtle complexities and dynamic rhythms to be seen in the hair is an opportunity for the artist to draw with a discipline that allows for a liberty of expression in the use of materials and application.

It is worth remembering that the hair and forehead take up over half the head. (Holbein must have been pleased to see Erasmus, who was a pinhead.) Hair is the element that can, both in reality and in the portrait, change the signal that the face transmits. Even a stray hair falling down across the eye can contribute a potent quality to a portrait. However the hair, whatever style or state it is in, even shaved, will follow distinct patterns of behaviour. It will always, however complex, begin and grow outwards from a central point, and will fall in distinctive clumps that are easily isolated and sectioned off for individual treatment, according to density and direction.

Drawing the hair is without doubt the most exacting and absorbing exercise for the student and time should be put aside for the particular study of it.

The hair accounts for almost half of the head. Its flexibility and infinite permutations complement and accentuate the immutable definition of a profile. It is almost as if the face represents the rational and the hair the protean natures of the mind.

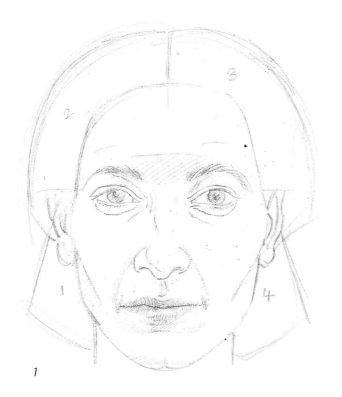

1

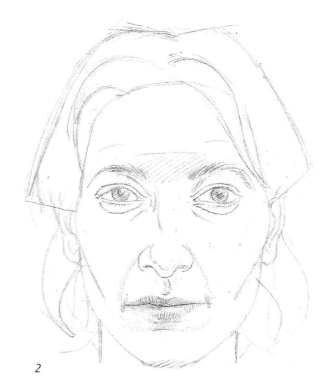

2

In this instance, when breaking up the hair into its basic sections it helps to try to regard it as a form of hat, rather than a complex mass of hair. Look for and isolate the particular shapes and contours, using a flowing line drawn from the wrist.

1. Isolate basic shapes within the structure of the hair.

2. Particularize the shapes, then erase.

3. Superimpose the flow of the hair within each shape in the order that they overlap. A quiff, for example, would be added last.

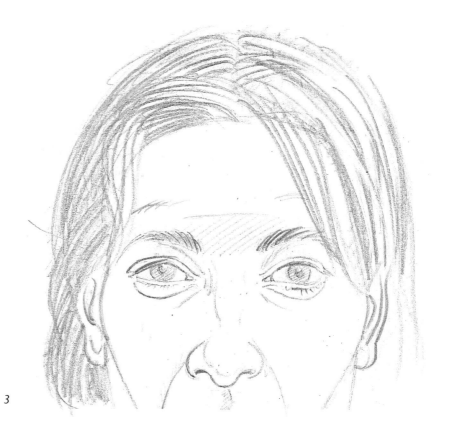

3

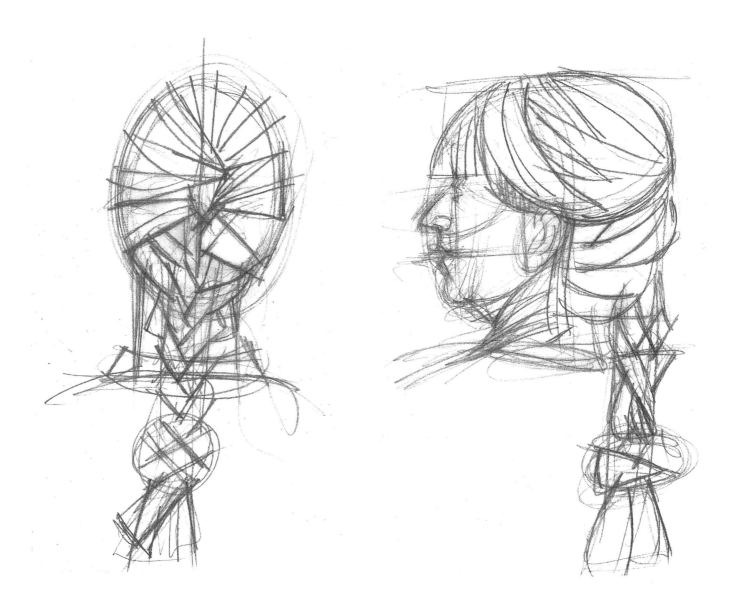

Start by breaking down the visual complexities of the subject into its basic shapes. Do not attribute the shapes with any meaning at this stage – in this drawing, for example, they could be seen as bandages as well as hair.

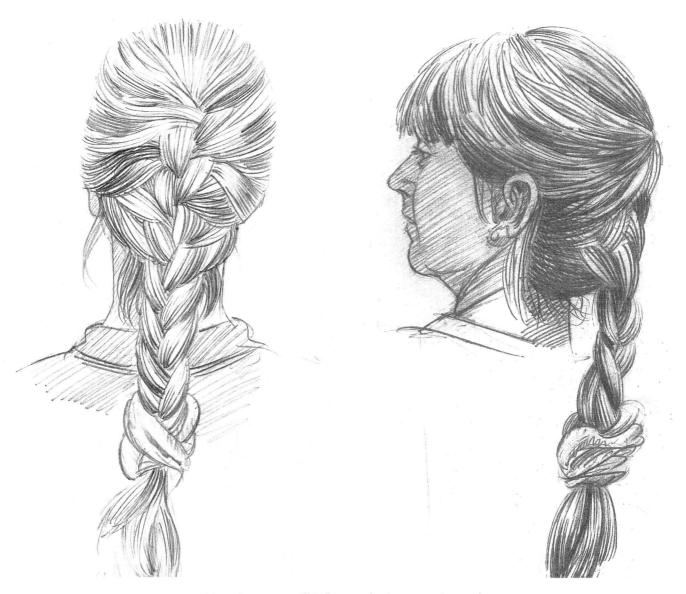

Although texture will influence the interpretation and manner of depicting a shape, regard it as its property rather than a subjective addition. In other words, do not introduce the sensation of hair until you have established its essential infrastructure. In this particular instance, the key word to access this image would be 'tension', due to the line tightening, expanding and tightening again.

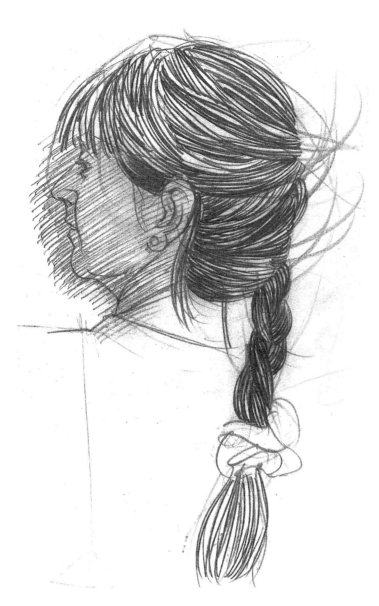

Use a 6B pencil to reinforce the edges of dominant sections of the hair. When shading do not hesitate to shade beyond the edges. This not only gives the shading momentun and regularity, but the excess lines can be erased afterwards.

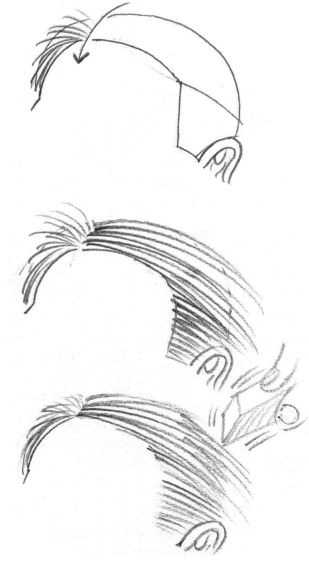

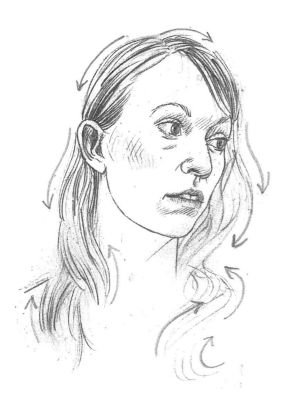

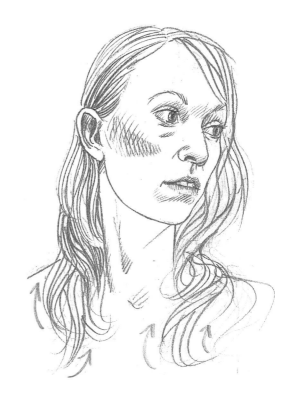

ABOVE: For loose, flowing hair begin, using an HB pencil, by establishing the general downward flow from the hair-parting, and remember that the hair is tighter towards the top. A soft 2B pencil would be suitable for defining the essential direction and convolutions of how the hair falls. The rhythm and flow of the hair can be achieved by working both down from the top and upwards from the tips

ABOVE RIGHT: Now use the eraser to draw in tongues of hair that overlap, and introduce the linear rhythms. Do not stylize or slip into repetitive forms, as these will look lazy and undermine the discipline of the drawing. When drawing the ends of hair, 'contra-flow' by drawing backwards from the tips towards the source.

RIGHT: Soften the hair where applicable with the eraser, and emphasize the darks between the fold of the hair.

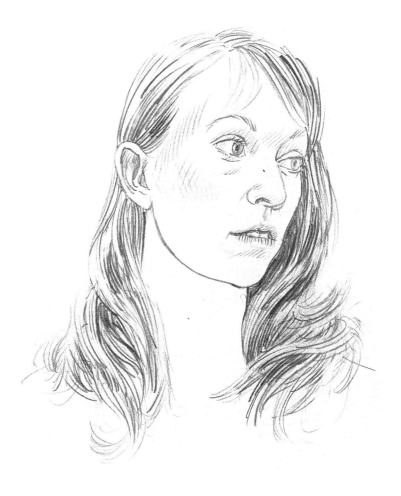

ABOVE: Draw the hair outwards from its source with firm, continuous strokes. Do not stop at the contours of the head – it will only break the momentum and the vitality of the line – but continue the natural course of the stroke. Use the eraser to trim the overlapping lines. (All that having to neatly colour up to the edges at school causes big problems later on.)

ABOVE: Gently erase areas of light into the hair, reducing the tone of the lines with appropriate pressure (A).

RIGHT: Notice how the French pleat seems to pull the face back into shape, highlighting the intriguing and peculiar beauty of the ear and the outline of the face. Also note that the collar provides a third interesting textural and structural foil to the other two sections of the head.

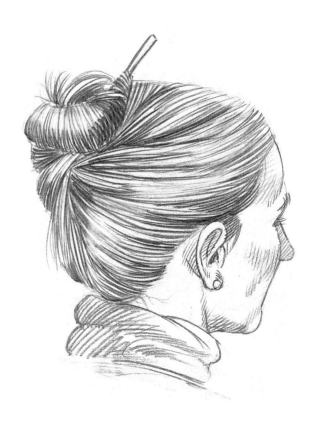

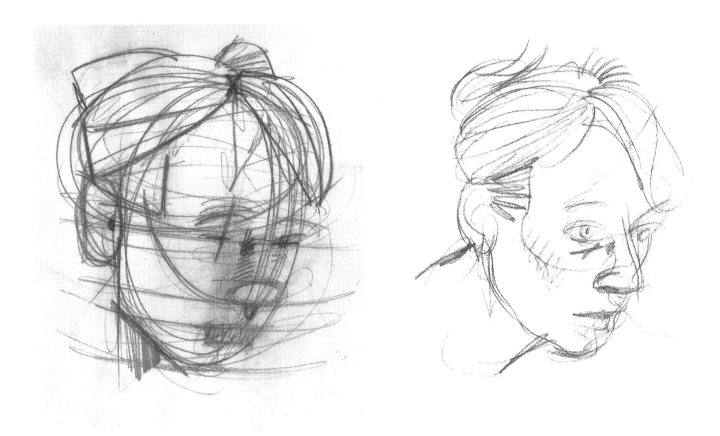

This portrait combines most of the methods used so far.

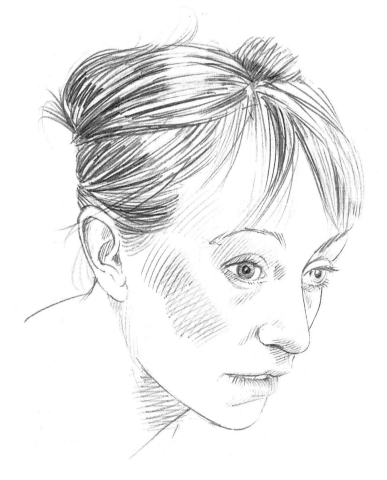

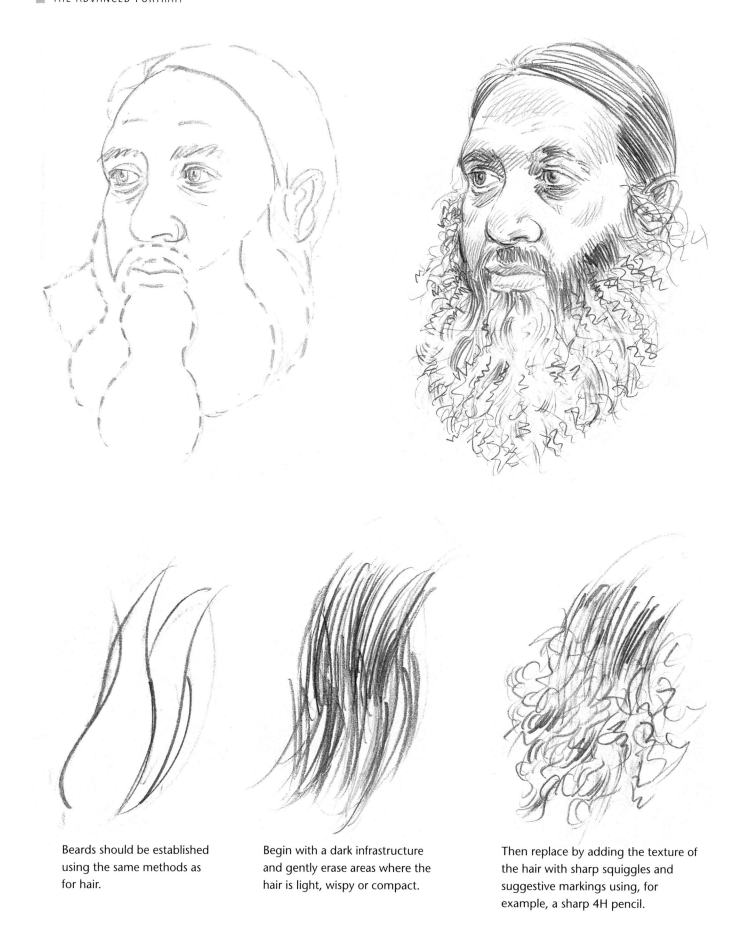

Beards should be established using the same methods as for hair.

Begin with a dark infrastructure and gently erase areas where the hair is light, wispy or compact.

Then replace by adding the texture of the hair with sharp squiggles and suggestive markings using, for example, a sharp 4H pencil.

The Neck and Shoulders

Imagine the neck as the wrist beneath a glove puppet. As the features of the puppet are being manipulated, the body is moved around in sympathy, helping to accentuate the expressions.

The neck is the plinth on which the head sits. It is not just something to fill a shirt collar or to hang baubles from; it is a highly vulnerable area that emphasizes our mortality with its disclosure of the jugular. It can signify our indulgence with its absence or dignity with its elegance and deportment. Therefore, when drawing the neck visualize it as a column, not as just two vertical lines.

Although the internal structure of the neck will be essentially the same in everyone, its external formation and the degree of prominence of the internal structure will depend on age and gender as well as the actual individual length of the neck. The basic muscles and bones of the neck and shoulder are shown on this page and opposite. It is these that are visible to varying degrees beneath the skin, especially when the neck is turned.

Just like in a classical bust, the portrait usually ends at the collarbone, where it emphasizes that the head is only part of the overall human form.

The neck is, of course, contradicting what has been said before: it is a crucial armature to hang (as in the Fayum Portraits) the trimmings and trinkets that make us a symbolic animal. When drawing the edges of clothing against the body, do not fix them to the edge of outlines. Imagine them enveloping the body, the lines continuing around to areas unseen.

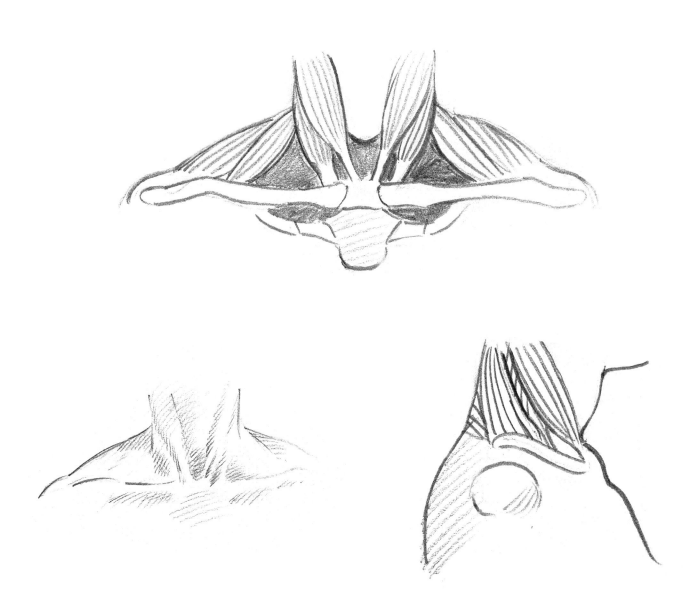

Shading

Shading should never be used to pad out a drawing as a final, habitual, addition. As much consideration must be given to it as to the linear forms of the face. Beginners, after carefully and painstakingly accomplishing linear satisfaction, often on impulse decide to vandalize their achievements with what amounts to mindless scribble. This is where shading sometimes becomes an attempt to add a spurious seriousness to the drawing or that 'finishing touch' that is deemed necessary in a work of art.

Shading should be used to complement the line. It should be used to realize form that the line can only inadequately suggest. Therefore it should be used considerately and sparingly and when specifically required, not to provide dramatic content to an otherwise weak image.

It can be used to emphasize certain features that would, normally, be remembered and noticed as particular personal features of the sitter's face. Sometimes a strong, defined, well-chosen collection of specific lines such as the edges of the cheek, the length of the nose and beneath the chin, can suggest the surface formation of non-linear areas of the face.

Shading does not follow any particular general method of application: sometimes the shading will follow the direction of the form; in many cases it will go against it. For the purposes of simplicity and as a basis for personal development, I have used a formal, general-purpose method of shading. Remember that certain areas of modelling require a sharp pencil and others a flat, soft point.

Shading also contributes to the momentum of the face, as well as reinforcing subjective qualities such as gentleness and experience.

We have now looked at developing a portrait in the same manner that you would probably employ when seeing someone for the first time: forming a general impression, noticing particularities and developing a sense of their character.

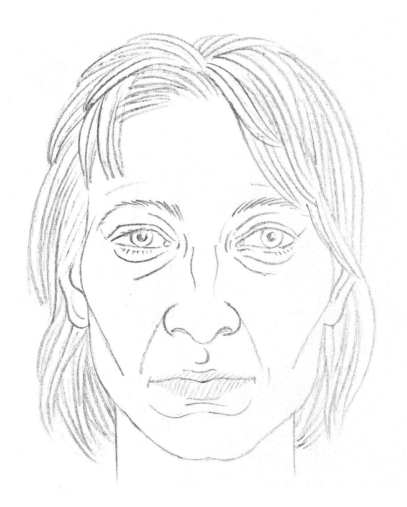

This formal portrait is now ready for shading and the further development and refinement of particular features.

The standard areas of shading

One of the most effective methods of shading is to ensure that all the shaded lines are drawn upwards, diagonally towards the right, regardless of what side of the face. This is because there is a tendency when beginning to shade from either side towards the centre.

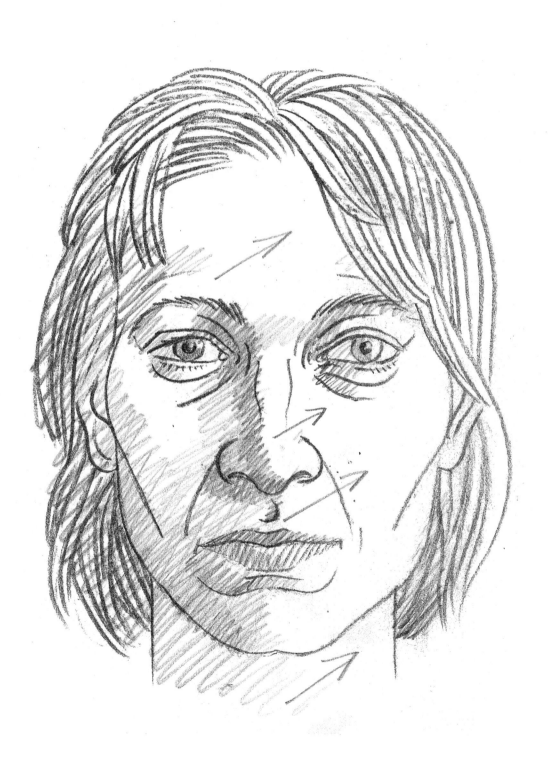

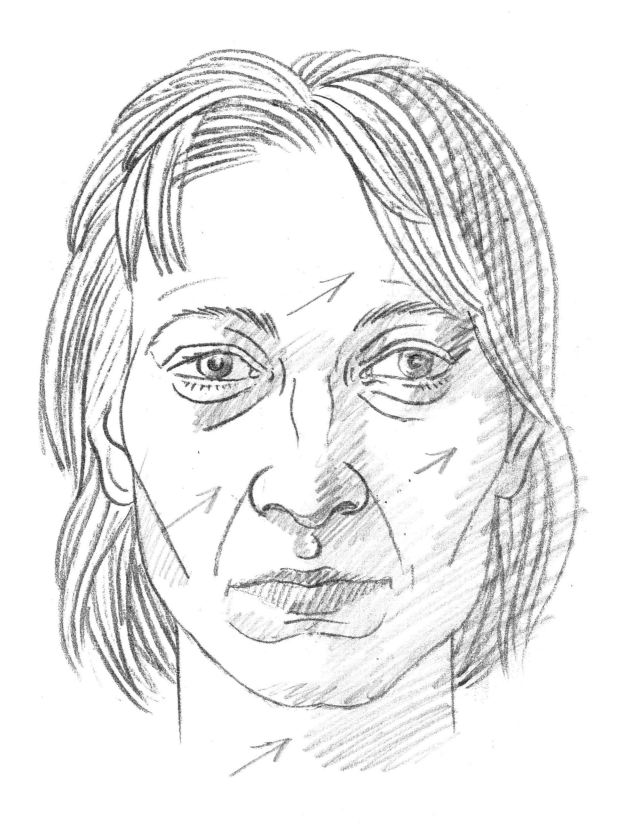

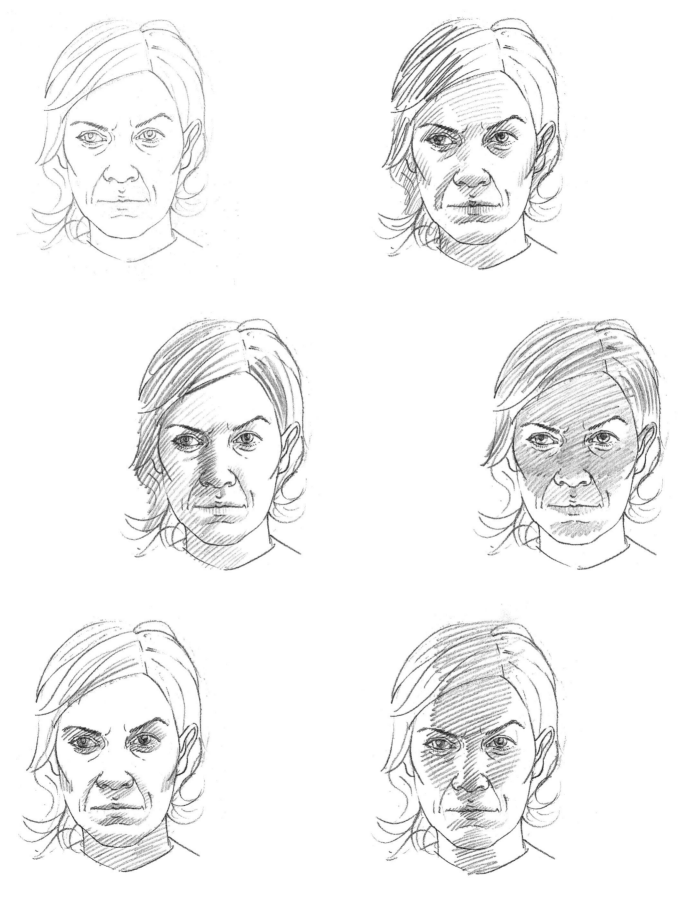

Different shading techniques

Create shading through modelling with line and cross-hatching significant areas. It is important to take note of the direction of the lines and the way they flow either with or against a form. Unfortunately there are no hard-and-fast rules regarding when or where each way is applied, but constant practice by simply doodling will enable the beginner to get a 'feeling' for it.

Look closely at the direction of the arrows in the right-hand column. The spaces between the lines should be diamond-shaped, not squares. Establish one direction first and then superimpose the other. The most effective way to practise shading is simply to doodle, concentrating on building up a flexible and variable rhythm. Another method of learning about the 'language' of shading is to study and copy etchings and engravings.

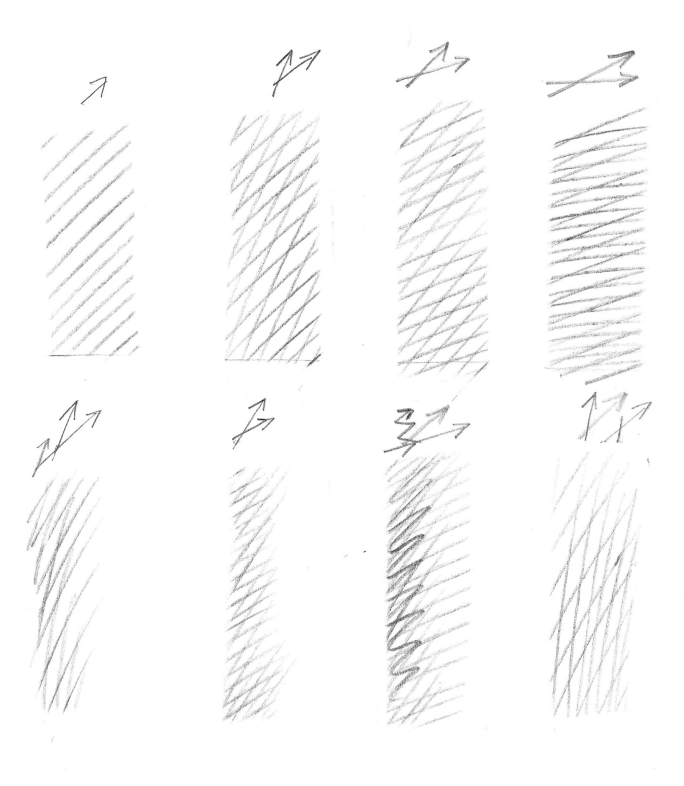

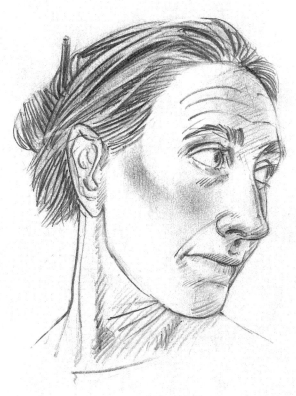

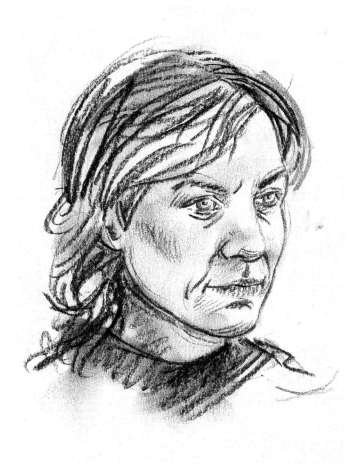

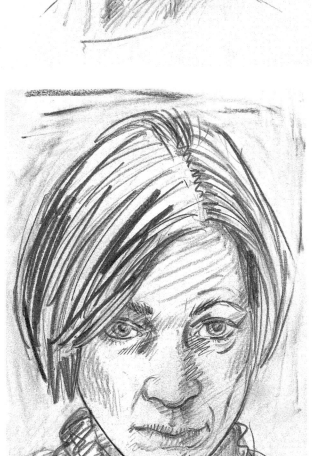

ABOVE LEFT: Using powdered graphite scraped off the pencil onto a separate piece of paper and then applied with the finger; it can then be shaped with the eraser. Take note that this technique must always be used in conjunction with linear shading, otherwise it can become monotonous and appear grubby.

ABOVE: Crayon pencil by its very nature will prevent a drawing from becoming too precise and detailed, and so will encourage a more considered and clear approach to the use of form and structure. When using charcoal pencil, use with a light touch and apply shading sparingly.

LEFT: Using a soft 5B pencil will allow a similar feel and quality to the line, as well as providing more opportunities for the variations of methods and techniques. A soft pencil can be used for decisive and vigorous lines.

The examples on pages 87–91 show a method of drawing where detail is subservient to form. The head is treated as a formal structure and is explored with bold, expressive lines in an attempt to understand its physical presence.

RIGHT: Allow for the natural strength of the features to establish the form of the face. Use shading to complement rather than dominate.

BELOW RIGHT: Firm and compact lines emphasize an aspect of a subject's personality.

BELOW: In this study the effects of old age have been interpreted and rendered in select areas of cross-hatching. The linear elements are established in short, 'bouncy' lines.

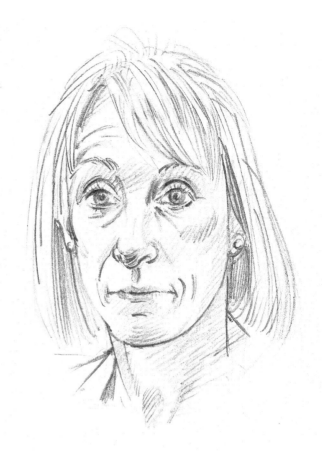

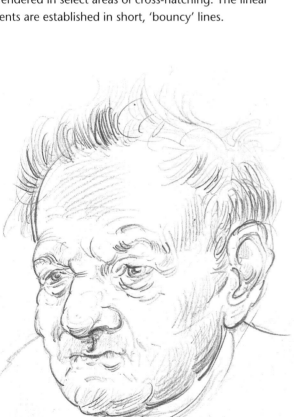

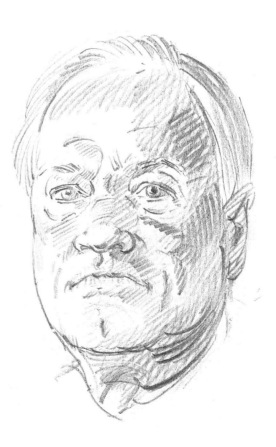

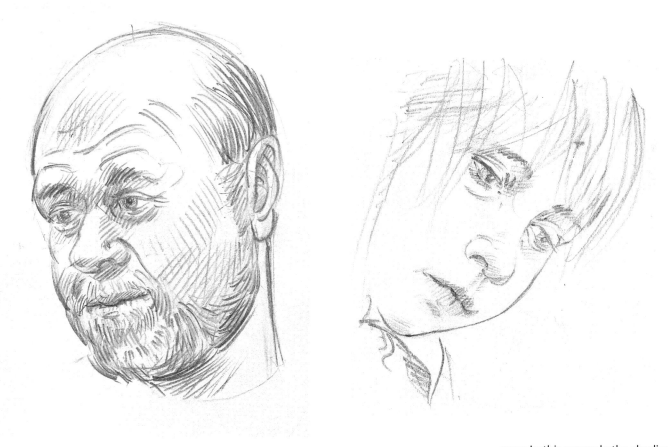

ABOVE: In this example the shading is light and the line is soft, in an attempt to capture an appropriate and sympathetic mood.

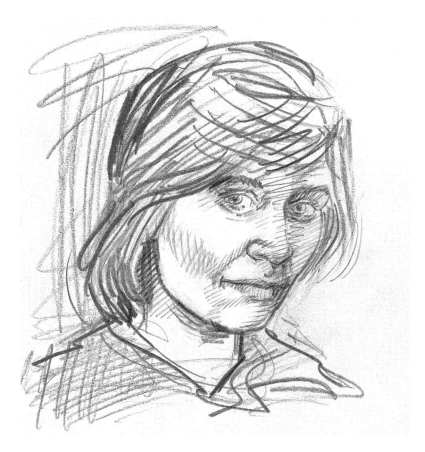

LEFT: A combination of different textures of lead and shading patterns can animate a portrait.

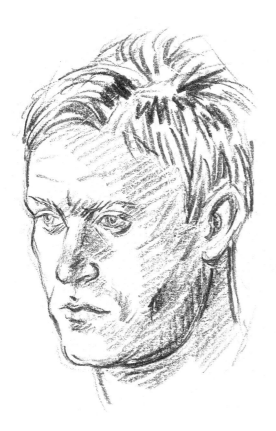

LEFT AND BELOW: A crayon pencil must be kept sharp at all times. As it wears down the ensuing bluntness is exploited by using it to shade simultaneously.

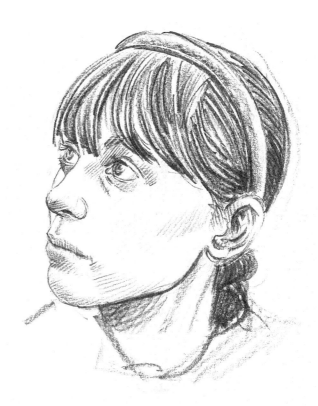

LEFT: Using both compressed and willow charcoal (as seen on page 92) you can widen the range and potential of a drawing.

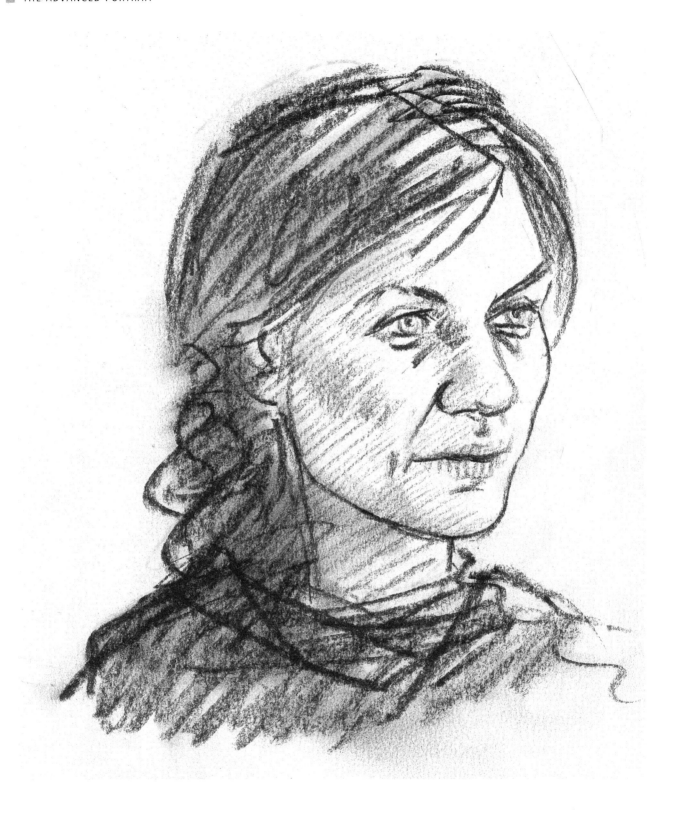

In this charcoal pencil study, the shading lines are not used to darken the drawing as this is done by an initial layer of smudging.

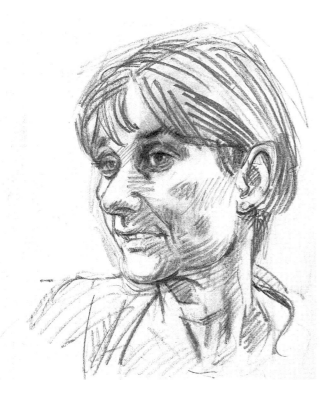

This type of study is best done against the light so that the details are indistinct; this allows the tonal values and the fundamental structure of the features to predominate. This approach is most suitable for making preliminary drawings for use in painting and sculpture.

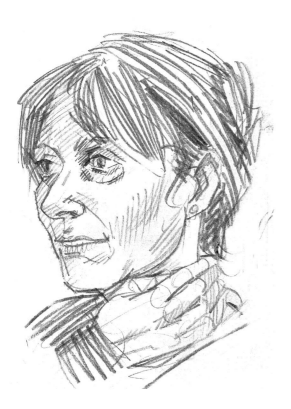

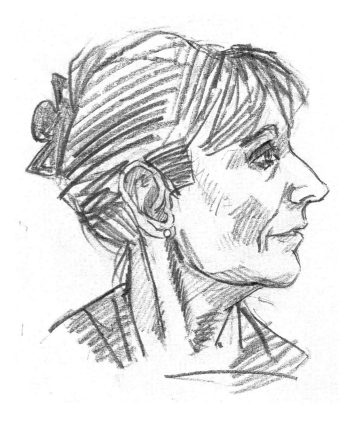

Tone

As in music, tone is something that is either inherent or acquired. Most people will either feel comfortable with extremes of tone or will settle for a neither-here-nor-there compromise. Degrees of tone in a drawing are achieved not only by the grade of lead used but, more importantly, by the pressure applied to the pencil.

The polarization of tone does not, as in the world, reflect the true nature of things. A complex of compromises is closer to the truth, generally speaking: if you feel, for example, that an area should be darker than would be commonly expected, you will usually find that it co-exists quite comfortably with other tones. Contrast must be pursued with a sophisticated, not with a heavy, hand.

Look around the studio for what you believe to be the brightest thing in the room (it's usually the model). It may be the electric light, but then compare it with, for example, a white wall and the daylight through the window. At first you will probably confuse the idea of brightness with the physical feeling of it. For example the white wall, if closely observed, is a fusion of different levels of grey. It is only categorized as white to be conveniently brighter than the electric light, which is yellowish. But in reality the brightest thing could be the glint on glass (when the

model discreetly turns her watch to see how much more she has to endure) which, like the glint in an eye, is extreme and fleeting. Therefore, arrive at a simple spectrum of tone ranging from very dark to the brightness of the paper, and use your eraser to achieve grades of tone in between.

It is usually easier and more effective to begin by using three moderate degrees of tone to establish contrast, and then to increase and decrease, not only in response to what is seen, but to the point where the drawing *looks* right.

Charcoal

As you become more experienced and familiar with different drawing mediums, it will become apparent that the particular qualities of each one will suggest an attitude to take towards the subject. To substitute one for another for the sake of convenience will make a lack of sensitivity towards the theory and practice of drawing glaringly obvious. For example, the dimension and definition of a pencil line is perfect for a considered and detailed observation, but cannot be a substitute for the spontaneous warmth and tonal subtleties of a charcoal line. Therefore, use charcoal in an expressive and confident manner to exploit its potential.

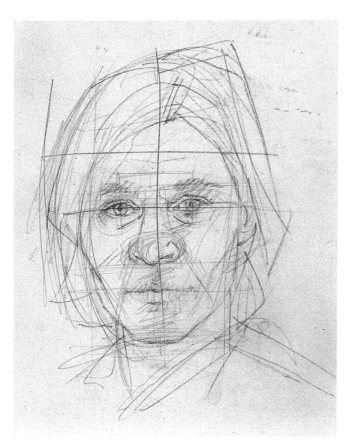

Lightly block in with soft pencil.

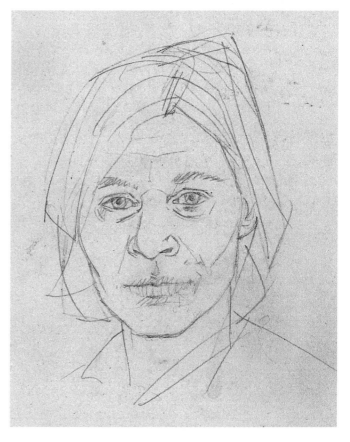

Delineate with compressed charcoal.

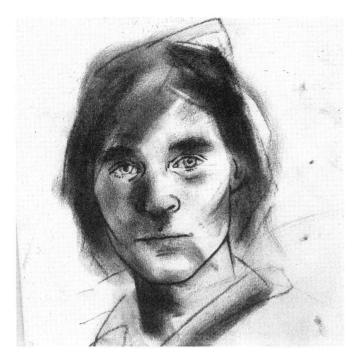

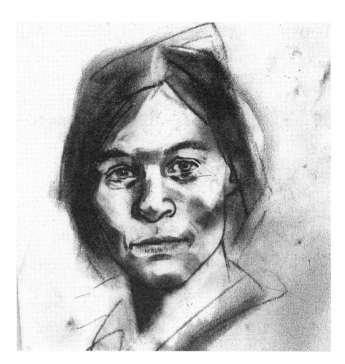

ABOVE: Scrape separate piles of 2B, 3B and 4B dust and apply the shading using a finger. Experiment with the different tones before hand.

ABOVE: Begin by adding a general dark tone in the approximate areas. Do not be too exact.

BELOW: Continue to develop the drawing using compressed charcoal (B) to define essential lines and willow charcoal to introduce subtle lines such as the texture of lips, crows-feet, gaps between teeth, etc. Gently use the eraser to graduate the tones.

BELOW: Establish areas of light with plastic eraser.

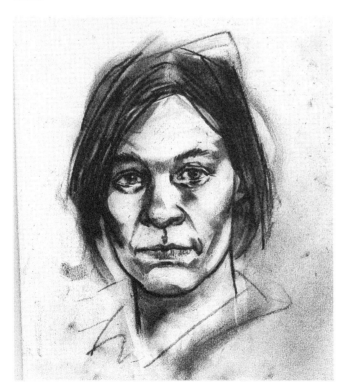

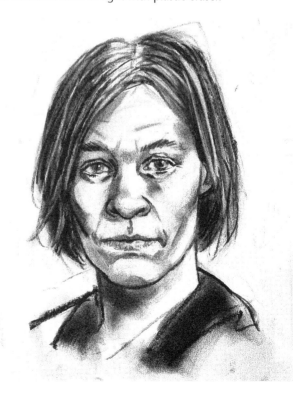

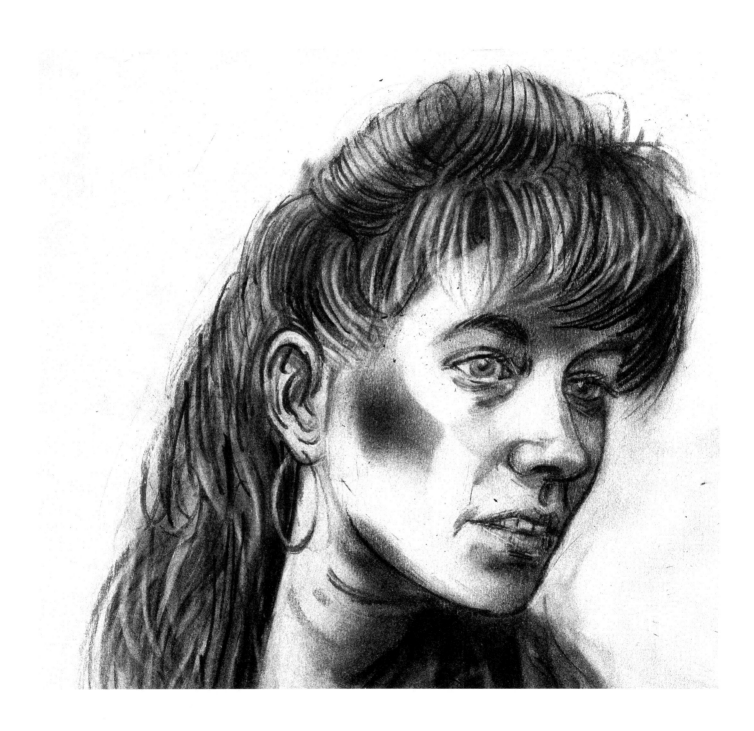

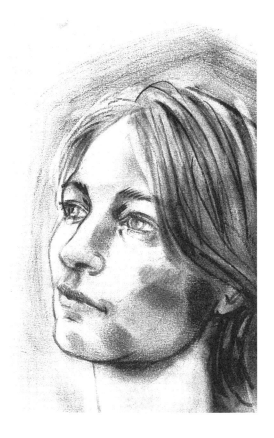

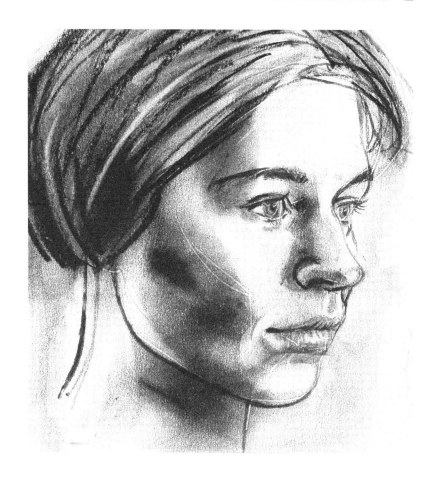

Using Compressed Charcoal

Compressed charcoal is denser and more intense than ordinary willow charcoal. It is also more difficult to control and has a far greater range of potential than willow. Therefore it should be used in a more restrained and considered manner, when deciding which grade to use. When using compressed charcoal, always begin by drawing lightly – in fact it is usually easier to use willow for the initial blocking in.

Always keep one end of the stick sharpened, and the other end intact to be used for extra-fine lines. Sharpen your stick into a lid (use a separate lid for each grade) and use this powder to apply shading with a finger. Apply the powder sparingly and with alternating pressure from the finger. The shading can then be shaped and modulated by the eraser.

Block in with willow charcoal and continue to establish the features using the methods described previously. Gently affirm the outlines with a Grade B compressed charcoal. Smudge on a light layer of tone first and then superimpose the darker lines. This example was drawn exclusively with willow.

When completed the charcoal must be preserved with fixative as soon as possible. However, once fixed, further darks can be added to accentuate existing ones, and the eraser can be used to produce more subtle tones. If you make such additions, remember to fix again.

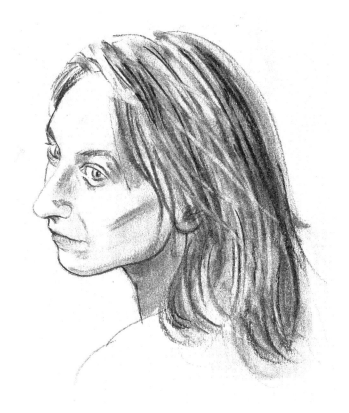

A sequence using willow charcoal

You can use fixative to fix each layer of the drawing so that it remains and is not lost in the next stage.

Gently erase with the side of the hand, and develop the form and structure.

Lightly establish the infrastructure as before. Remember to treat willow charcoal gently to slowly and gradually build up the layers of observation. The edge of the side of the palm is used to partially erase the lines as they progress.

Use a piece of fine sandpaper to sharpen and shape the point of the charcoal stick.

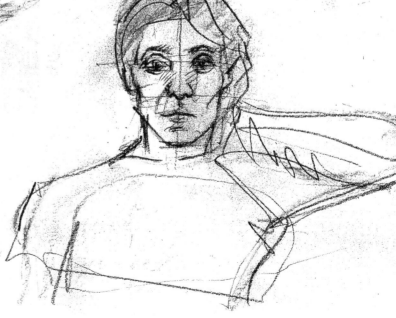

Begin to define using more pressure on the charcoal.

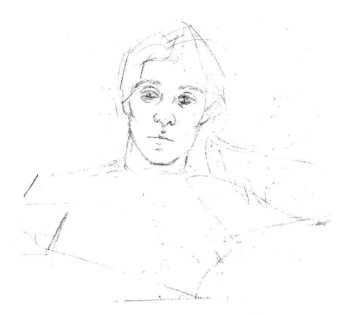

Gently erase with the side of the head, and redefine using more accurate and softer lines.

Continue to establish all the fundamental lines.

When completed fix the drawing with fixative.

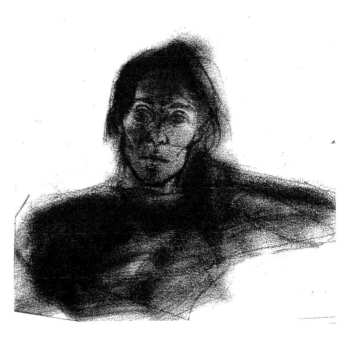

Gently smear a covering of charcoal dust over the drawing.

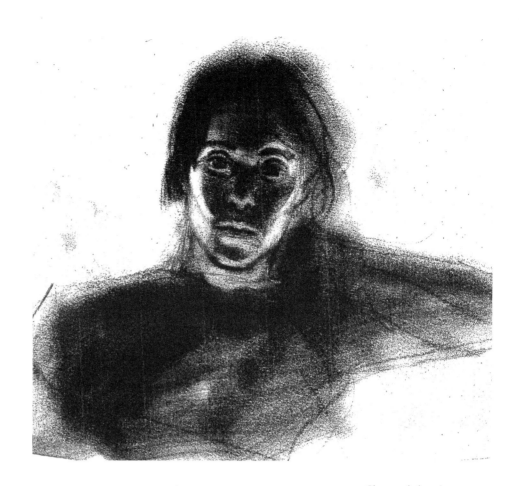

RIGHT AND BELOW: Introduce light with the eraser and strengthen lines where applicable.

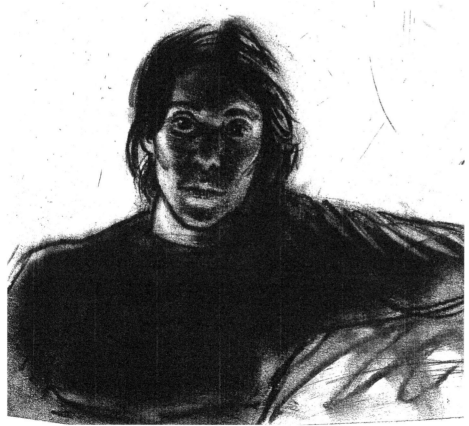

OPPOSITE: Charcoal drawing. Notice how the charcoal has been applied in layers. Each layer is erased with the side of the palm, and the eraser is used towards the end.

Each layer is composed of lines of different thicknesses and tone. In a drawing like this it is important to maintain a momentum, otherwise the image will become too controlled and finicky.

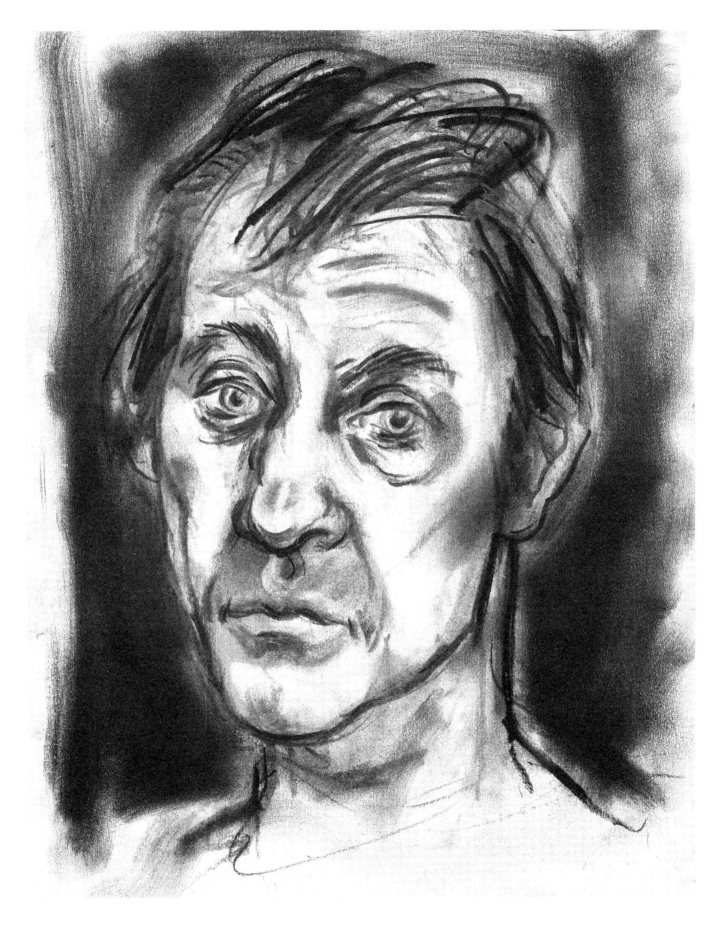

The Head at Different Angles, and in Profile

RIGHT: Take note of the width of the lower jaw and the position of the cheekbone. Also notice the width of the cranium, because it is longer than one might imagine, especially when covered by hair.

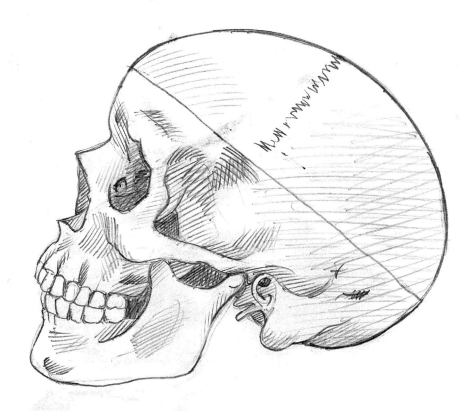

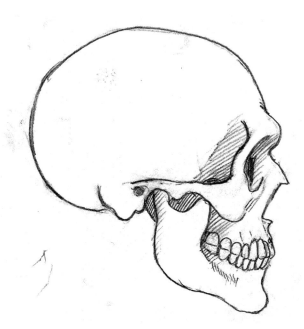

A male skull. Once again, compare the shape of the brow and the dimensions of the jaw with that of the female.

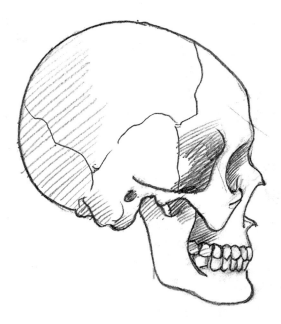

In the female skull the brow does not protrude and the jaw is thinner. Also, the shape of the skull is not as elongated.

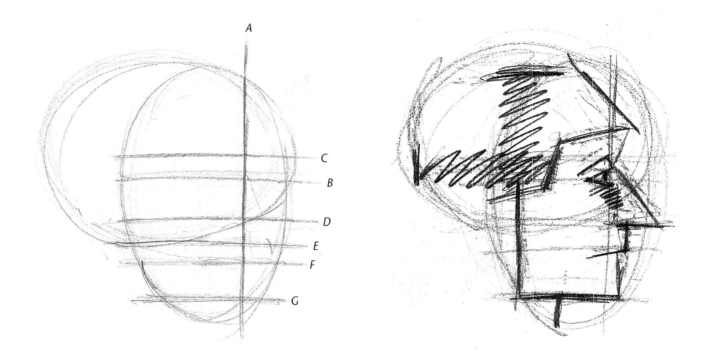

ABOVE: Roughly combine two ovals to arrive at the basic shape of the head. Place the nose line (A) through where the pupil and the corner of the mouth would be. Then add the rest of the lines of the face where they would normally be: (B) eye, (C) eye, (D) nostril, (E) bottom of nose, (F) centre of mouth and (G) chin.

ABOVE RIGHT: Use shading to easily establish distances and block in the basic positions of the features. Erase.

RIGHT: Refine and define forms. Erase.

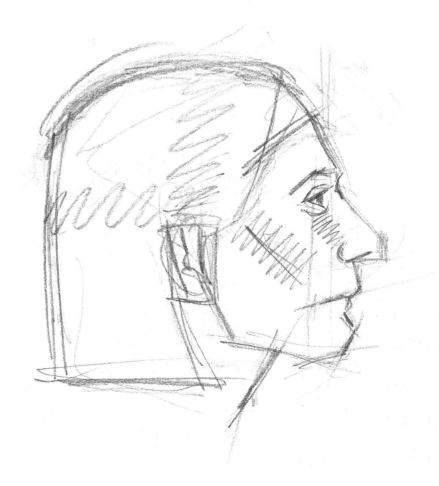

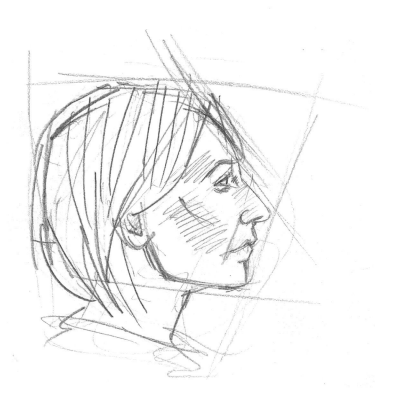

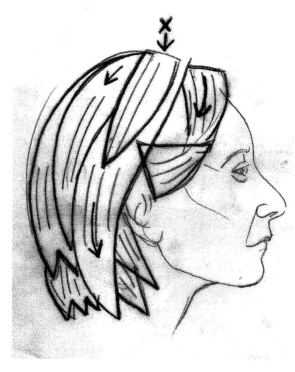

ABOVE LEFT: Develop the likeness, and correct the angles and scale of the head.

ABOVE: Identify and isolate the shapes within the hair. Erase.

LEFT: Personalize and bring to completion.

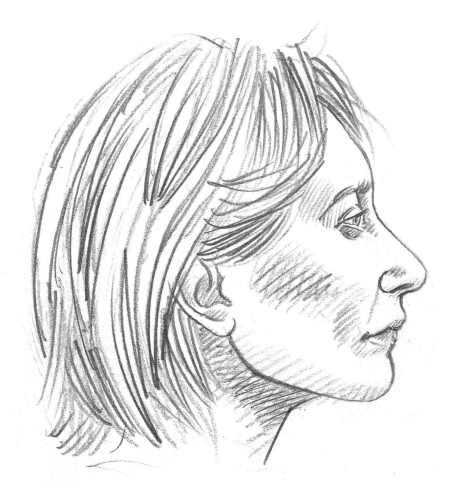

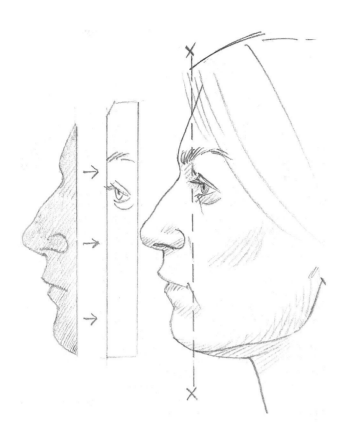

ABOVE: Take note that the eye sits behind the line and the nose, mouth and chin begin on the other side. In most cases the nose and the mouth rest on a line in front of the eye. Even if this is not the case, it can prove to be an effective starting point for making alterations.

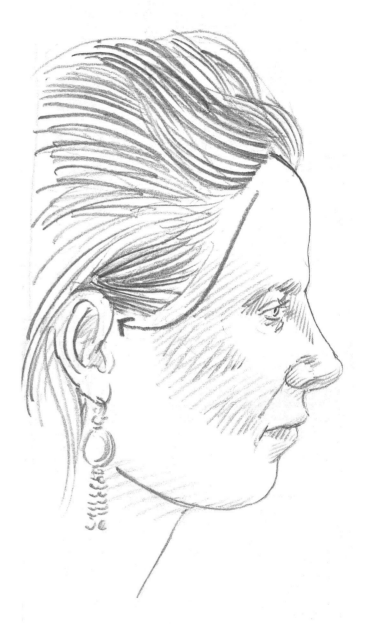

RIGHT: Once again, pay attention to the height and angle of the forehead. To find the position of the ear, follow the line of the edge of the hair across, down and across. Use the shading method to arrive at the approximate borders of the head.

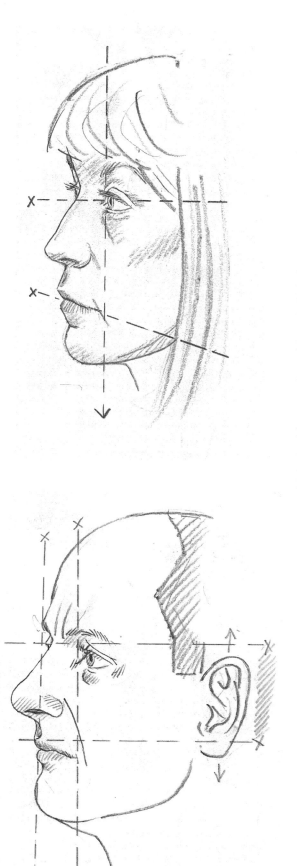

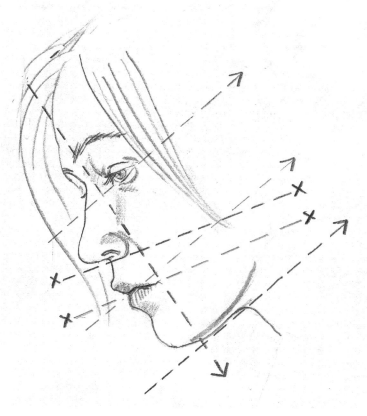

Notice how the centre line of the mouth, as well as the bottom of the nose, usually slants downwards and not straight across, and how the distance between the nostril and the corner of the orb can vary immensely.

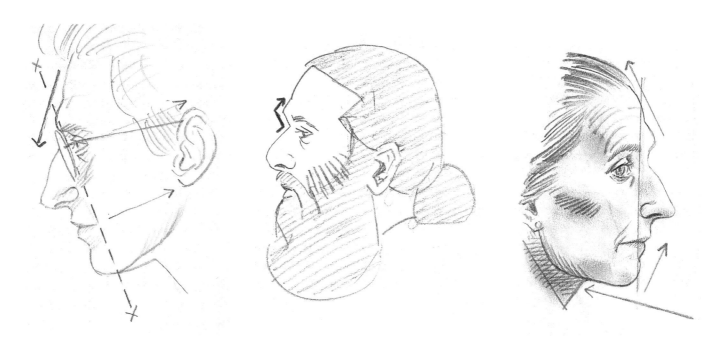

Pay special attention to the angle of the forehead because this can be steeper than presumed. Also, the lower part of the face is sometimes angled up towards the nose, and the jaw angled downwards from the ear.

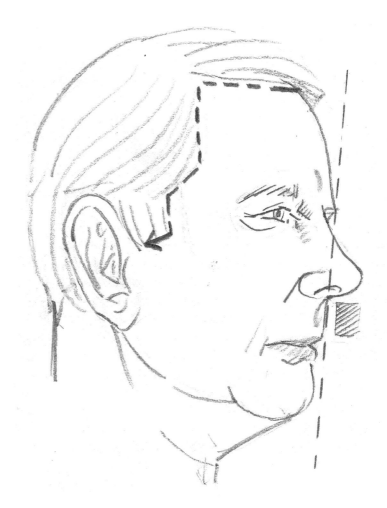

Now a formula for creating a profile has been established, alas as is the norm in art, it must be treated with caution. In many instances the entire features of the face can, but for the end of the nose, be placed behind the base of the nose line. This goes to show that nothing should ever be taken for granted in the visual world, and that every portrait should be regarded as a unique beginning and should never be reduced to a conceit or entertainment.

The Head in Three-Quarter Profile

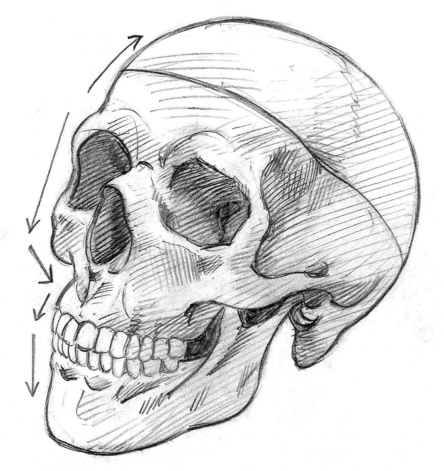

Take note of the angles and structure along the side of the skull. This is the most common angle in portraiture and, although it is not as difficult as it first appears, there are certain areas such as depicting the furthest eye and the contour of the furthest cheek that can cause problems for beginners. Therefore pay special attention to these examples.

To prevent the far side of the face from losing its moorings, objectively shade in the shape of the upper and lower cheek. Reduce the shape of the mouth and eye to triangles and ensure that the eye is attached to the edge of the nose.

Using the edge and angle of the nose as a guide, reduce the shapes to triangles and shade the shape of the cheek as it appears along the edge of the face. Pay special attention to the passage from the tip of the nose to the top of the chin.

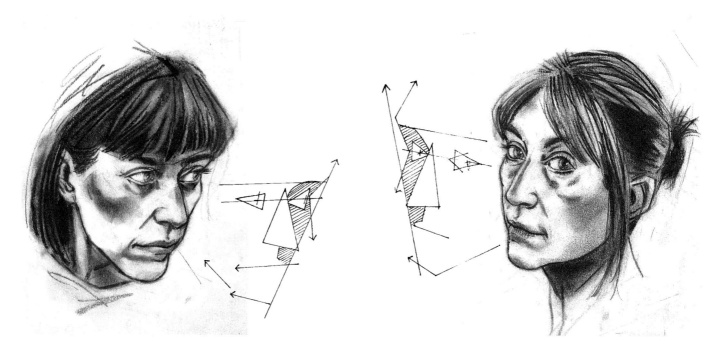

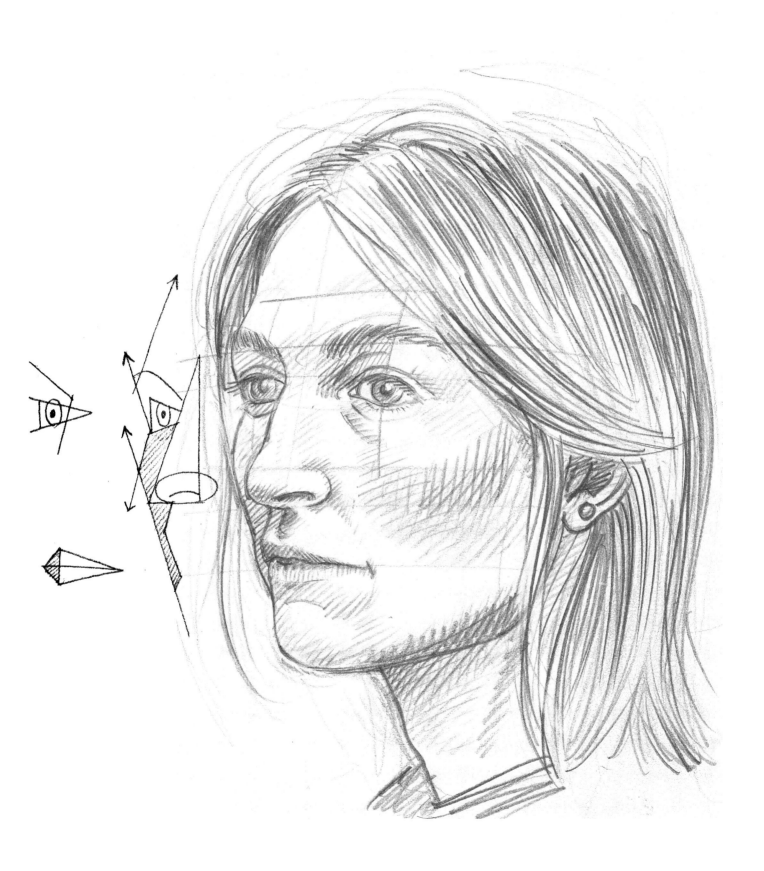

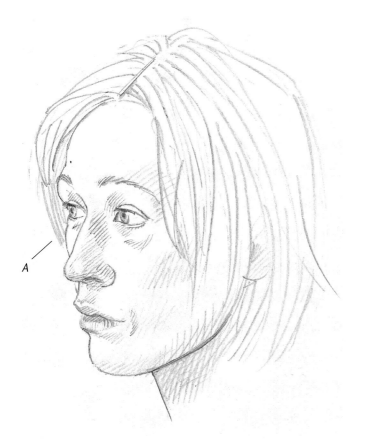

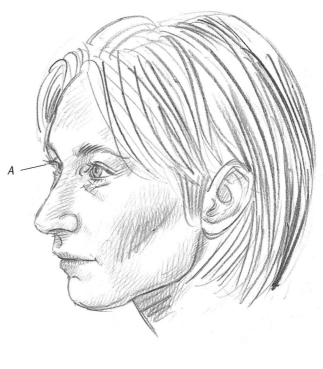

See how the visibility of these contours is affected by the slightest turn of the head. Once again notice the difference in the contours of the outside edge (A), but also notice the subtle difference in the shape of the eyes. This is not due to their respective angles but to the fact that they are in fact physically different. Therefore, do not feel the urge to 'tidy things up' or alter things to conform to a notion of normality, as this can result in loosing a likeness.

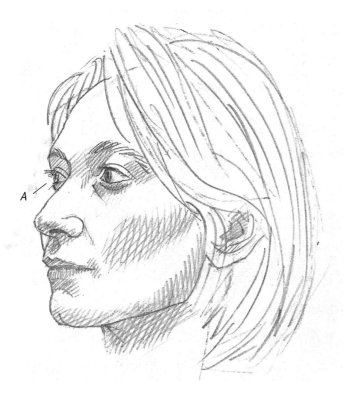

Establishing a Three-Quarter Profile Leaning Away

Begin with the correct angle of the eyebrow line and the nose line. Then continue the drawing sequence as has been shown before.

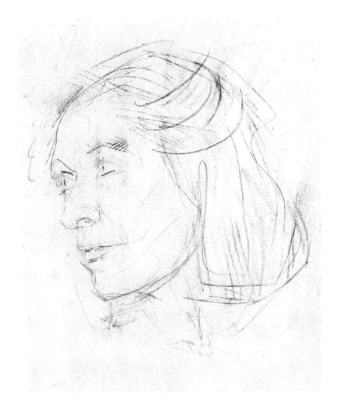

…and then erase.

ABOVE: Establish the structure and then erase.

BELOW: Develop the structure of the face…

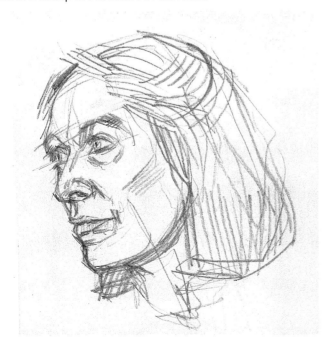

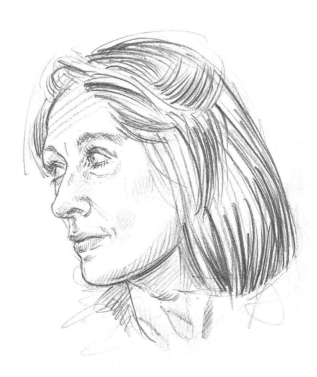

Refine the quality of the line, paying particular attention to the form and weight of the hair.

The Face Seen from Above

BELOW: The head from above forms a triangle and the spaces between the lines of the face 1, 2 and 3 can alter drastically in individual faces. Pay attention to how the eyebrow line is not straight, but curves upwards.

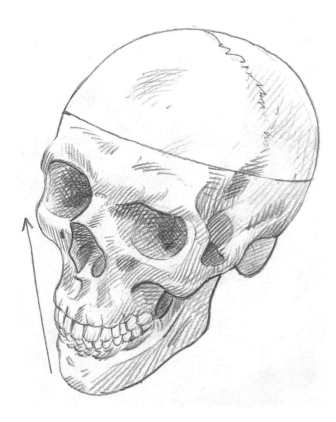

ABOVE: When seen from above the face can be placed within an inverted triangle, with the mouth and chin becoming greatly reduced and the nose not only becoming predominant but altering its shape where sometimes the base of the nose becomes wider than you imagine. Notice the size of the top of the skull compared with that of the lower part of the face. Also notice how the orbs become ovals, and the angle of the sides of the face.

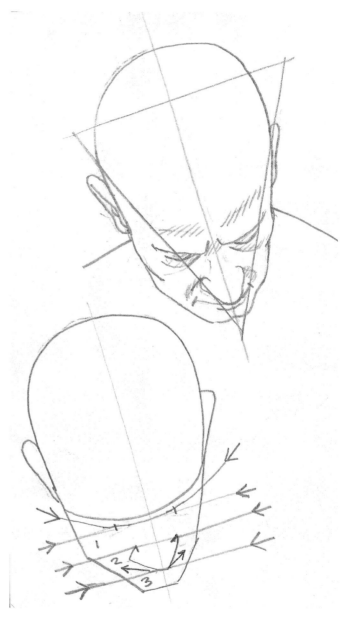

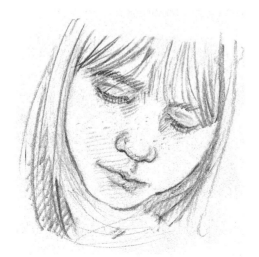

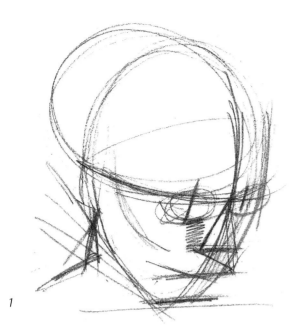

1

2

1. Establish the shape of the head using two egg cups. Introduce the beginning and position of the nose with a triangle.

2. Draw in the centre line over the top of the head and use it as a guide to begin defining the shape of the hair.

3. Most of the shading should be around the lower part of the face. Try to keep the forehead clear and unfussy.

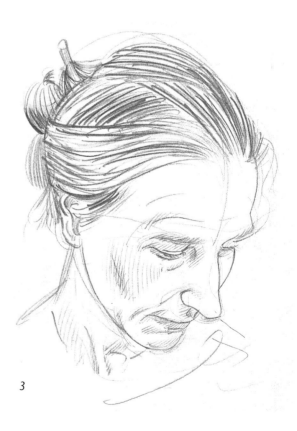

3

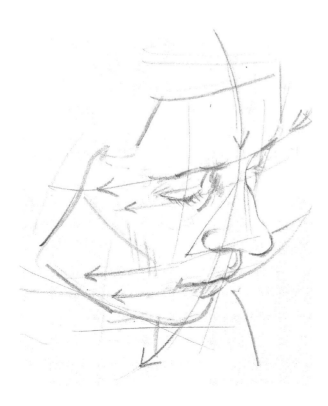

Ensure, to begin with, that the eyebrow line curves downward and around. Note that at this angle the top of the skull takes up almost two-thirds of the head, and that the line of the mouth is not straight but curves upward.

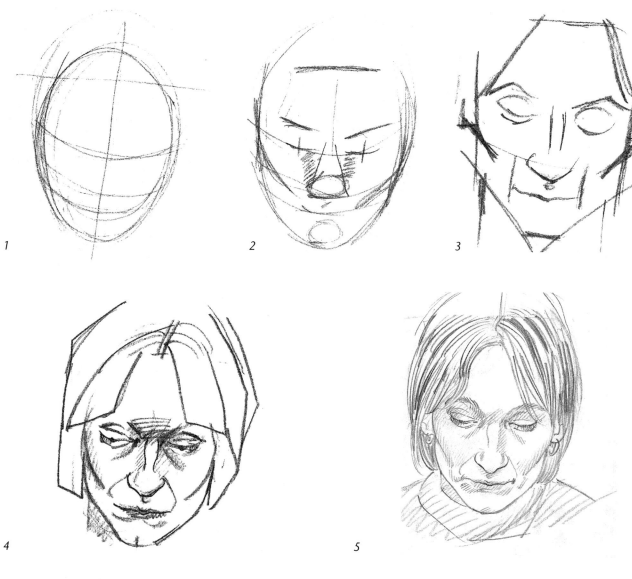

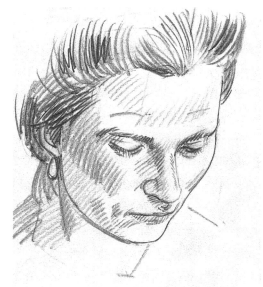

1. Block in the egg shape, ensuring that the eyebrow line, etc, are curving around the egg in the right direction: upwards.

2. Establish the position of the nose by using a triangle. Use an oval for the chin and mark in the cheek bones.

3. Establish and define the angles of the features.

4, 5. Put in basic shading and now gently erase as done before to create the infrastructure for the finished drawing (5).

6. When the face is lowered the forehead will usually appear to be rounded or flat, and surprisingly large. This is usually due to the fact that, when looking at a face in normal circumstances, the attention is focused on the activity of the rest of the face. Because of this there is a tendency to reduce the dimensions of the forehead to subjectively comfortable scale.

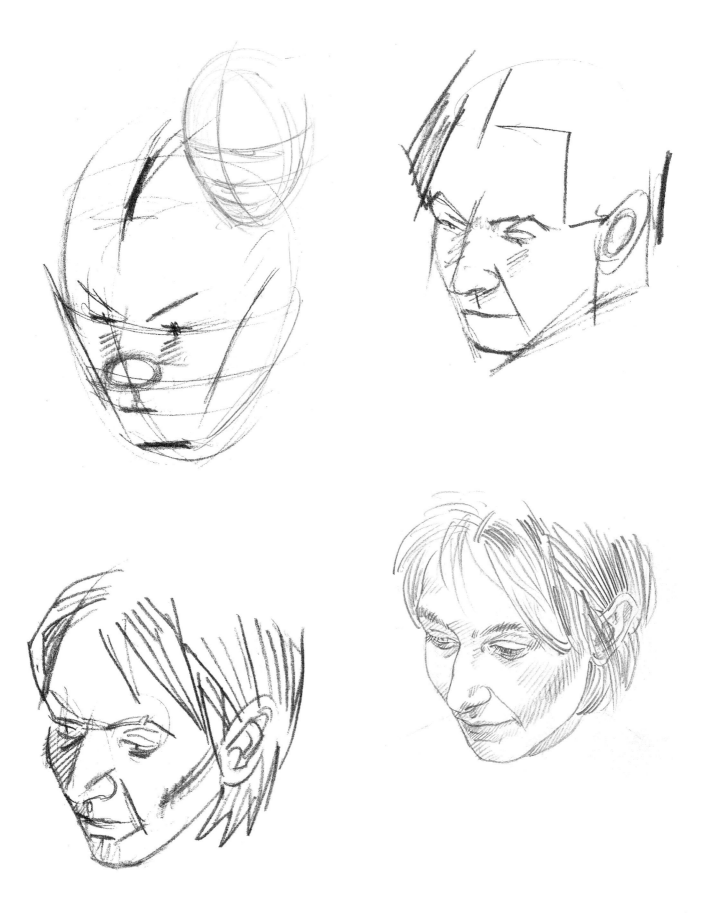

The Hand

The hand, when visible in a portrait, in effect functions as a prop: a support for the head, or to accentuate or continue an element within the portrait by another means. For the purposes of this book I am only dealing with the hand when it has contact with the head.

When considering how over-familiar we are with our own hands, it is extraordinary that when we come to draw them we are literally all fingers and thumbs. The complexities and innate strangeness of the hands make the prospect of drawing them a formidable undertaking, and yet the process of understanding structure, once understood, can be applied by the student to any undertaking, be it architecture or a galleon.

One exercise to practise that needs nothing more than a pencil and the generous participation of yourself is to draw your own hand drawing your own hand (it beats a Zen monk's one-handed clapping).

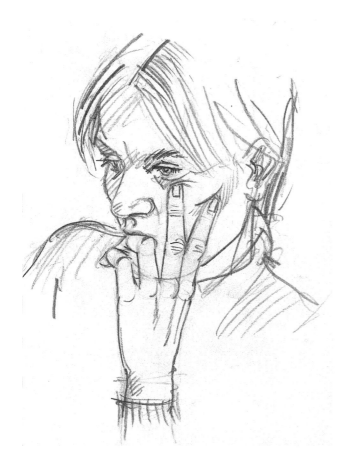

Guidelines for drawing the hand

Be objective at all times and maintain the idea of the hand's function in your mind as you draw.

When drawing the fingers, begin with the little finger and work up and along the rest of the fingers from there. This enables you to have the smallest reference point to measure from, as well as helping the rational side of the mind to 'switch off' what you assume that you know and to concentrate on what you actually see. This will ensure that, however awkward an angle appears to be, it will always look correct.

The key points to remember are:

1. block in
2. define
3. re-define
4. work from the general to the particular.

Always, it must be emphasized: introduce the hand when the head is complete. Superimpose the hand over or against the face.

Do not fit the head around the hand. Do not stop at one edge when drawing the chin and begin again at the other side: draw through existing lines and then simply erase to remove the lines that are not visible.

The same goes for headwear. If you cannot see the top of the head, just assume it is there and block in. Do not stop the forehead or hairline neatly at the rim of the hat.

NB: For the sake of clarity, the hand illustrated on the left has been drawn slightly larger than life-size.

The hand is basically a square for the palm, an oblong for the fingers and a circle for the base of the thumb. Do not see or treat the fingers as four individual units; instead, see them as a rectangle with three dividing lines. If they are treated independently of each other there is a tendency for them not to relate: they will individually grow forever larger and more cumbersome, and will eventually resemble a bunch of bananas or at best a rubber glove.

Note two important points:

- The palm is not actually a square but is a slightly leaning rectangle with a top edge that slants down towards the base of the little finger.

- The thumb when relaxed sticks out at a 45 degree angle and that there is a web of skin between the thumb and forefinger.

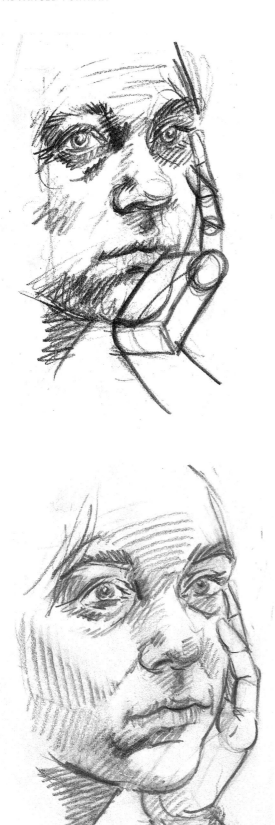

LEFT: Begin the hand by establishing the base of the hand first and then start with the smallest visible finger. This allows the eye to make objective sense of the potential complexity of the fingers.

BELOW LEFT & RIGHT: Notice that the hand is placed and positioned using the little finger as a guide over the previously drawn line of the jaw. To find the correct spacing between the fingers simply shade in, temporarily, the space seen between them. This is usually referred to as the 'negative space' and is now frequently used as a 'Learn to draw in a day' technique. Unfortunately, if it is used as the sole means of arriving at an understanding of the subject, it can be likened to learning a word by just knowing the consonants and ignoring the vowels.

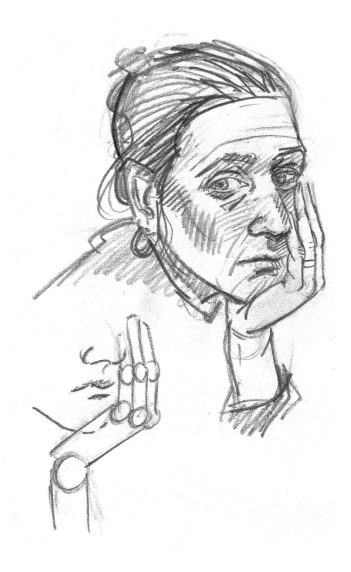

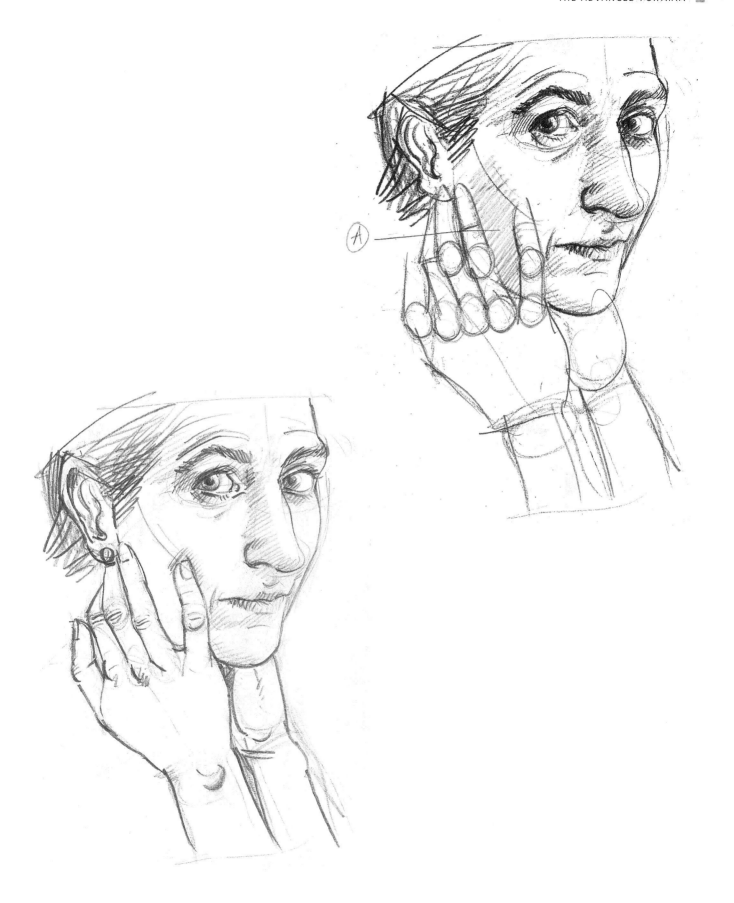

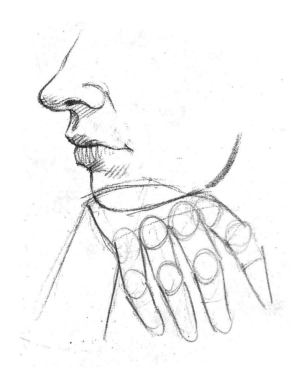

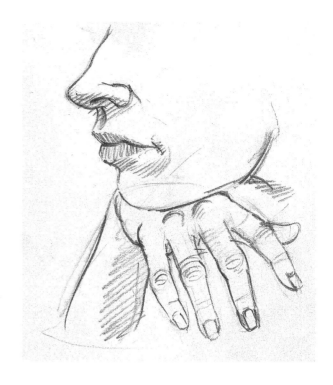

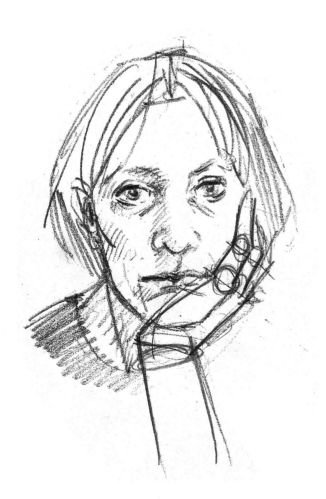

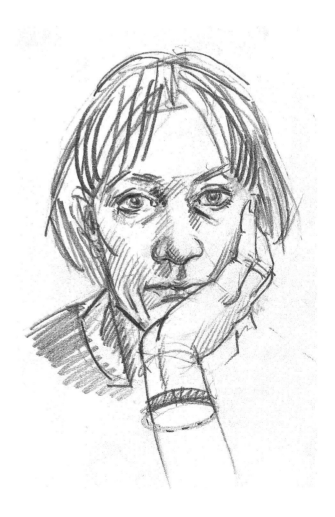

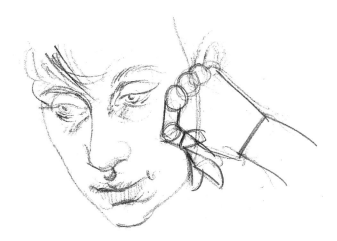

Shorthand Studies (Thumbnail Sketches)

You should now be familiar with the drawing process and the methods and essential structural lines that constitute a face and head. Therefore you should be able to develop, at leisure, shorthand to capture character and likeness in 'sketchbook' studies that will enliven and contribute to the authenticity of your observation.

Walk into any gallery and you are bound to see a very earnest artist scrutinizing a portrait painting whilst scrawling with a pencil into a sketchbook. If you ask what they are up to you will probably hear the word 'transcribing', which refers to a rather self-important, profoundly serious and ostentatious method of making a sketch. Don't be made to feel inadequate because you may be assured that nothing can be gained by this except attention. If you are copying a painting you would, sensibly, use paint.

Above all do not draw, simply, for the sake of it.

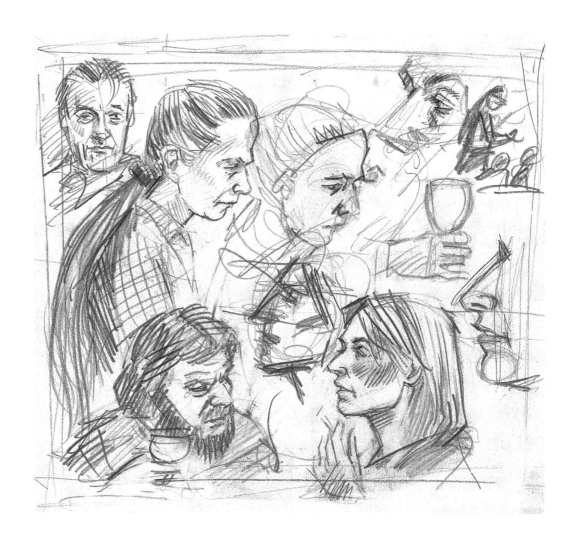

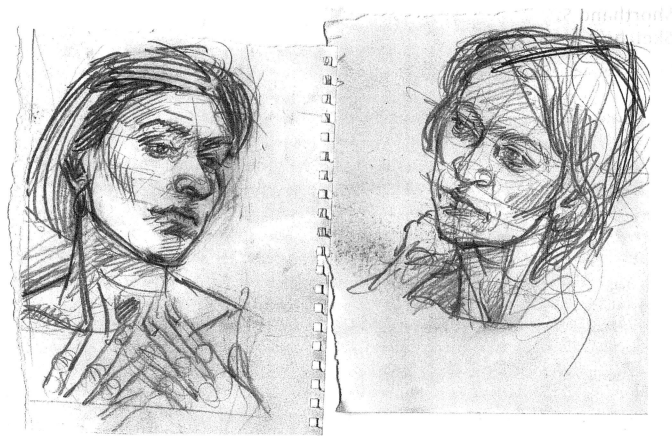

ABOVE: Initial studies.

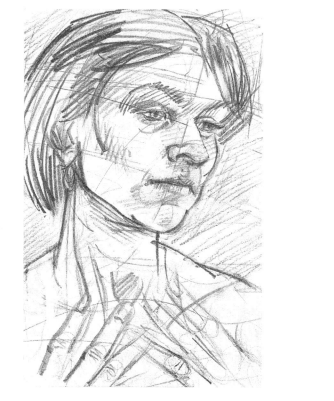

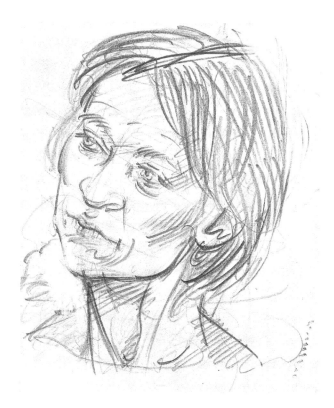

Initial studies developed and clarified. It is important that this is not overworked, so that they maintain their vitality and freshness of observation.

Caricature

Finally, a short introduction to the rudiments of caricature. (Firstly, put aside a sharp pencil and mark it 'poison'.) This can be invaluable when either waiting for the model to turn up late or not at all.

Using the essential lines of a formal portrait, the student can experiment with manipulating, without necessarily distorting, the grammar of the drawn face. The basic essence of caricature is based around the exaggeration of the senses as in a big mouth, big ears, small (mean) lips, wide (stupid) eyes, and so on, and should confirm that never a truer thing is said in jest.

In portraiture the desire to unravel the mysterious secrets of a likeness and, hopefully, the personality of a person is not really different from observing people's behaviour and how it physically manifests itself. Both disciplines require a sound working knowledge of basic anatomy and the ability to represent complex combinations of disparate elements in a clear and concise way. The art of cartooning not only depends on a sense of humour and lateral thinking, but also requires the same levels of attention as does portraiture to the quality of the drawn line and to the potential of the materials that are used.

Dabbling in caricature is a good way of learning about the importance of restraint within a formal portrait, where there is always a danger, especially with distinctive features, of it becoming theatrical and mannered. It also helps in realizing that, unlike restraint and subtlety, ugliness and exaggeration are a lot easier to achieve and can result in an emphasis on style over content. This unfortunately is quite prevalent in contemporary portraiture, where the fine line between generalization and particularization is indistinct due to an ignorance of the difference on the part of the artist.

Draw with a soft, flat, pencil using the basic 'grammatical' forms of the face: try to 'write' the image rather than draw it. Try to maintain a continuous rhythm, allowing one shape to suggest and complement another. If you observe a cartoonist working you will probably notice them contorting their face in sympathy with the emotion being drawn.

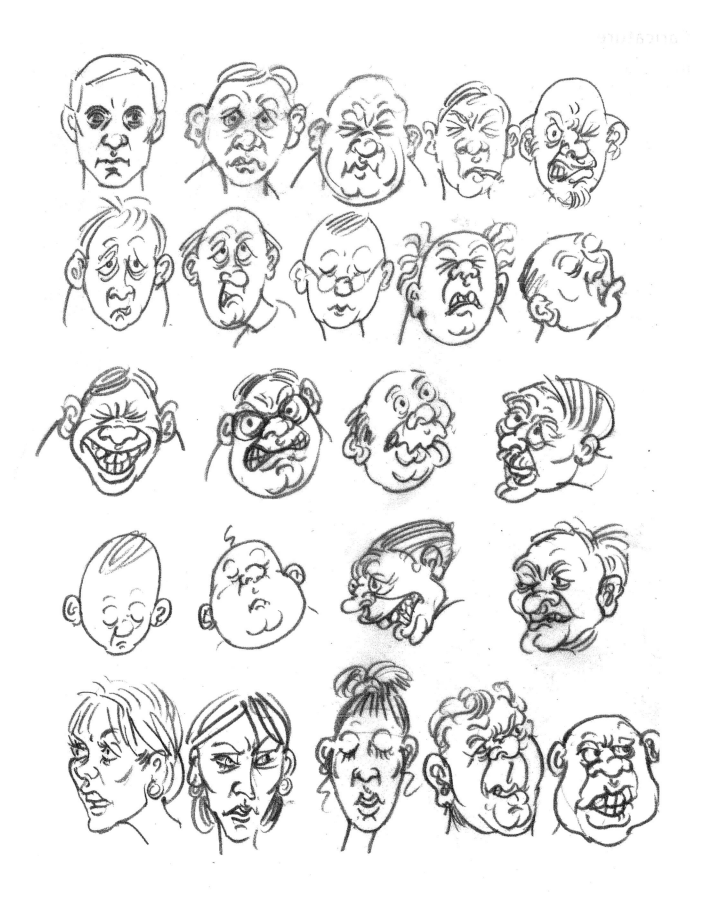

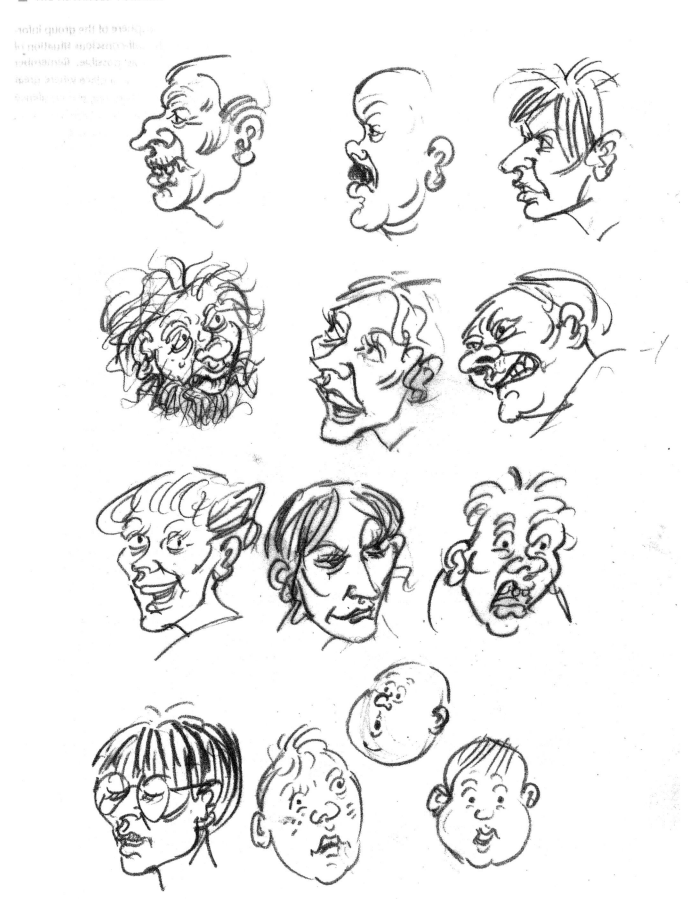

Drawing Together

Inevitably, at some stage the beginner will nervously need to join an established art group. If this is the case, try to find a tutor-led group with an established agenda that is influenced by the tutor's own personal approach to the theory and practice of art. A good tutor will not only inspire and prove by example, but will lead you to realize, clarify and understand things that were already hidden there dormant.

Do not feel that beggars can't be choosers when looking for guidance, especially when your ambitions are simply to develop your drawing abilities. There is always the risk of joining a group where, unlike drama and choral societies, proven basic ability is not a criteria for membership and, as in all groups, members will probably have personal agendas not directly concerned with the demands of art. In fact, a lot of groups actually cease to draw and learn, or even to learn to draw, and instead operate within the hazy world of art as a leisure and pleasure pursuit. This is completely at odds with the fine art tradition, which is instead replaced by a cosy regime where weaknesses are mutually seen as strengths and nurtured by nebulous rules of conduct that evolve into a rabid fundamentalism. Where thou shalt not use black or Chinese White, trees to the left, cottage to the right (with vertical smoke) and Cézanne is dangerously modern.

If by chance there are no opportunities available, a viable alternative is to start your own study group in the same spirit as book clubs. This may appear presumptuous, but if your aims are purely to pursue learning rather than dreams of earning, it should be considered an option. For example, assuming that it is a portrait class, you will not have to encounter the sometimes, extraordinary behind-the-scenes situations that tutors have to endure to acquire life models, as well as the necessary space and paraphernalia that it requires. Therefore I have listed below some guidelines that may help you to avoid some common pitfalls when trying to organize and run a group that will continue after the first coffee break.

1. To begin with, care should be taken when inviting new members to join the group. Try to avoid exhibitionists who, with their box of tricks, flaunt their experience and their 'style', because their boredom threshold and competitive streak will usually undermine the confidence of the group.

2. At the beginning the group should establish a common aim and the general direction that the meetings will take. Is it going to be a loosely based 'everyone for themselves' affair, or a more structured and considered approach with the emphasis on mutual development rather than individual ambition. Once this has been decided upon, it is paramount that it is adhered to so that the group can remain focused.

3. Try to keep the attitude and atmosphere of the group informal and as far removed from the self-conscious situation of a religious or political gathering as possible. Remember that the origins of the academy was as a place where great thoughts were walked and talked. Therefore, serious silence and serious frowns don't necessarily mean serious work; in fact, in most cases where someone complains about noise when trying to draw, it usually means that they are not concentrating enough and are probably using their mind and not their eyes. In my experience, background music not only assists the mood and rhythm of the drawing process but helps to disengage the intellect and its obstructions.

4. Be flexible with how you use the time allotted to a pose and do not feel obliged to fill the time with perfunctory dawdling on one drawing. Instead, have a number of them on the go or just sit and meditate on the subject before you. Drawing should not be regarded as a time-based chore, a 'rolled-up sleeve, honest day's labour' affair finished off in a hissing, wheezing cloud of fixative.

5. As you are not working within a competitive situation, do not then undermine your confidence by feeling that you have to show your work to anyone outside the group. There is often lurking in the shadows maybe a family member eager to make light of your aspirations and endeavours; possibly even someone who, suspiciously, when life models are involved wants to see evidence of what you have actually been doing.

6. Try to sustain the sense when you are together that you are working within the living tradition of fine art and that this should permeate the *raison d'être* of the group. Therefore, instead of discussing non-aligned subjects such as sport, cars and grandchildren, aim to discuss artists and exhibitions – which you should forever be organizing yourselves to see.

7. Now of course comes the question of the model. It is very important not to treat the selection of a model as a case of 'anyone will do'. Just as in the cinema and advertising, success is in mainly finding the face that fits. Choose the model carefully to suit the particular aspect of portraiture that the group has chosen to study. For example, it is usually a good idea to begin by using faces with character because big noses, big ears and big hair ensure, at least, that arriving at some kind of likeness is likely.

Each session should concentrate on at least two aspects of the face. Use the method to establish an agenda for progress and remember that, for example, ears can be seen from four angles together and separately, therefore making a substantial addition to your knowledge as well as to the portfolio.

Make it very clear to the model, regardless of how amiable they are, that for the duration of the pose they must

not move or speak. It is prudent when selecting a potential sitter to look for evidence of nervous tics, talkativeness, unexplained laughter or fluttering eyelids. Dancers and gym users usually feel the need to overtly stretch their necks and rotate their heads at the slightest opportunity.

Models, in the absence of a tutor, can be an invaluable source of criticism when asked to look at work with a fresh eye because, not being able to assess the work against themselves, they have to look at the work objectively. This has the added bonus of their taking on the sensitive role of critic, which could otherwise jeopardize the social life of the group.

8. The above recommendations are made with the foregone conclusion that each member of the group will have their own, personal, copy of this book.

Finally, as an afterthought it sometimes seems that there is a compulsion amongst students not only to sign any scribble with a confident flourish absent in the work itself, but then to record the time that it took to produce it.

This overwhelming desire to simultaneously show off ability and excuse shortcomings is to be avoided. The drawing, the signature and the time are three different issues on the same piece of paper. I have the urge when reading 'quick pose 4 minutes' to suggest that with another hour it would have started to get better. (William Blake would advise the student to shake off those mind-forged manacles.) It would be more productive to make quick studies of a long pose and, in the self-satisfied moment of timing and signing, to try to squeeze in the model's name as well. (No doubt it will be pointed out that this is something I've neglected to do myself, but inconsistency is a perk of the job.)

When, as will be inevitable, you are cross-eyed and tired of it all and wished you'd stuck to colouring books, take a break to flick through some master drawings and let them seduce you back to the drawing board. Then sharpen the pencil, keep your eyes fixed ahead and if you *think* you've looked, stop thinking and look again, and allow the wonder of it all to gain control again. And, if still despondent, remember what Thomas Gainsborough, the consummate artist, said on his death bed: 'We shall all go to heaven and Van Dyke is of the party.' And, no doubt, will also be the mysterious Fayum artists, and maybe you will finally understand what Toulouse-Lautrec meant when he said before he died: 'At last I do not know how to draw anymore.'

It goes without saying that, having mastered the majesty of the human face, the student should, calling upon their entire reserves of ability, be ready to engage with the awesome face of the ultimate portrait in art itself.

FURTHER READING

Books

These are artists who considered drawing and portraiture as a significant part of their work. If you would like your own work to develop and mature, then you must understand that practice is not enough and that the study of the Masters is, to put it bluntly, mandatory.

Bell, Keith, *Stanley Spencer: A Complete Catalogue of the Paintings* (Phaidon, 1992)

Berger, John, *Permanent Red – Essays in Seeing* (Readers and Writers, 1960)

Brockhurst, G.L., *A Dream of Fair Women* (National Portrait Gallery, 1986)

Checketts, Linda, *Norman Blamey RA* (Norwich Institute of Art and Design, 1992)

Doxiadis, Euphrosyne, *The Mysterious Fayum Portraits – Faces from Ancient Egypt* (Thames and Hudson, 1995)

Hayes, John, *Rowlandson – Watercolours and Drawings* (Phaidon, 1972)

Hebborn, Eric, *The Art Forger's Handbook* (Cassell, 1997)

Kendall, Richard (ed.), *Degas by himself* (BCA, 1992)

Livingstone, Marco, *R.B. Kitaj RA* (Phaidon, 1999)

Marlborough Fine Art, *Van Gogh's Life in his Drawings* (Marlborough Fine Art, 1962)

Metropolitan Museum of Art, *Portraits by Ingres – Image of an Epoch* (Metropolitan Museum of Art, New York, 1999)

National Museums and Galleries of Wales, *Themes and Variations – The Drawings of Augustus John 1901–1931* (National Museums and Galleries of Wales, 1996)

Parker, K.T., *The Drawings of Holbein at Windsor Castle* (Phaidon, 1947)

Searle, Ronald, *Ronald Searle's Golden Oldies 1941–1961* (Michael Joseph, 1985)

Singer Sargent, John, *Portrait Drawings* (Dover Publications, 1983)

South Bank Centre, *Toulouse-Lautrec* (South Bank Centre, 1991)

Wyeth, Andrew, *The Helga Pictures* (Viking, 1987)

Individual Artists Worth Investigating

Jane Allison – a leading English portrait painter.
James Cowan – a serious Scottish artist
Dick French – an independent English artist
Hoshi Jila – a reclusive English visionary artist
Terry McKinney – an idiosyncratic intimist
Andrew Moran – an uncompromising figurative painter
Roderick Murray – an English painter based in Warsaw
Robert Sosner – a 'painter's painter'

INDEX